U0112211

慢游中国 只道寻常
CHINA ADAGIO

王身敦
ANDREW S.T. WONG

著

电子工业出版社·
Publishing House of Electronics Industry
北京·BEIJING

To Chris and Jasper

引言

刘香成 / 文

普利策奖得主
美联社前驻华首席摄影记者
上海摄影艺术中心（SCoP）创始人

我在20世纪80年代就认识王身敦。当时，我们在相互竞争的西方新闻机构工作，他在路透社，我在美联社。然后，我们俩先后告别新闻摄影工作，转而从事各种独立的项目；在这期间我们偶然也有机会合作，我很珍惜这些机会，我一直很欣赏王身敦的摄影方向，以及他那勤奋、投入和认真的工作态度。

这里展示的作品的时空、地域和题材跨度很大；这些多元化的作品都有一个共同的特质，就是透过深思熟虑的框架呈现深刻的敏感性。这些影像展示了大小城市以至偏远地区的人们的日常生活场景。这些人对日常生活有着根深蒂固的习惯和态度，而随着社会的发展，这些习惯和态度正在从外在和实质上有明显改变。这些照片既展示了一种我们熟悉的感觉，那种我们认识和共鸣的情感音色的共同性，亦同时具备独特的文化特质以及一个民族的传统符号。从20世纪80年代的早期照片到2010年后作为独立摄影师期间的作品，尽管相差近30年，王身敦依然可以一直保持他的风格——自然地、真实地抓住某一时空的瞬间。

在他还是一名摄影记者的时候，王身敦便以无与伦比的耐心对待他的工作。后来，当他成为一个独立摄影师之后，他更加投入大量的时间和精力，仔细观察出现在他身边的人和自己周遭的日常生活状态。生活犹如发动机，它得以成功运行全依赖于活在其中的人们所给予的动力。尽管一切都在发生变化，生活节奏也在加快，但王身敦经常游刃有余地抓住那些偶然的时刻，把那些瞬间呈现在不经裁剪的定格里，那是一种静止的感觉，给无休止的运作带来停顿感。我将其称为"不缓不急的中国肖像"。值得注意的是，正如照片的说明所示，王身敦曾到过中国一些人口很稠密的地区，例如四川，然而在他的照片里出现的人们却依然流露出一种宁静与安逸的感觉。现代社会在全球化的大环境下急速前行，但普通民众在参与追赶的同时，并没有放弃自己所拥有的习惯和熟悉的生活方式。王身敦看到的，就是这些照片所显示的，即人们以适合自己的步伐，寻觅自己的幸福。这本书里的作品涵盖如此广泛的主题和广大的地域而得以维持这种感受的连贯性。王身敦在《慢游中国：只道寻常》里成功地实现了对寻常人和事既敏锐又深刻的描绘，这确是一项了不起的成就。

自序

王身敦

从 20 世纪 80 年代到今天，从少年到白头，近四十个年头，在这片土地上，我从一名过客变身成为一位居民。我喜欢慢慢地游走在这古老的国度里，遇见不同的文化，看着无数的脸孔、身影，听着不同的故事……

这里，有人民有生活，有情感有故事。场景可以是街头，是市场，是车站，是学堂，是江边……人物可以是被怀抱的孩子，被搀扶的老人，看风景的情侣，扛重担的挑夫……动作可以是跳舞，是过路，是锻炼，是谈情，是买卖，是游园，是遛狗，是看相，是卖艺，是下棋……

一个人，两个人，三个人，几个人——人的分布、关系、层次，以至每个人的神情、姿态，他们身处的环境，进行的活动，层层叠叠，相互交接；这些人们，就在身边，是熟悉的，也是被忽略的。

平实的人们，他们从何而来？会走到哪里？他们的过去、现状、未来；他们立足的社会，所属的民族，拥有的历史……他们的背后，有很多故事。

— 信誓 —

在重庆的日子里，我听到一个古老的传说。

廪君务相与盐水女神的故事，就发生在这里，即古代的巴国国都，现在的重庆。传说，远古时候巴人部族首领廪君，带领族人寻觅宜居之地，路过盐阳，遇到盐水女神，他们之间发生了一段浪漫哀怨的故事。刘向《世本》这样说："……乃乘土船，从夷水至盐阳。盐水有神女，谓廪君曰：'此地广大，鱼盐所出，愿留共居。'廪君不许。盐神暮辄来取宿，旦即化为虫，与诸虫群飞，掩蔽日光，天地晦冥。积十余日，廪君不知东西所向，七日七夜。使人操青缕以遗盐神，曰：'缨此即相宜，与女俱生，不宜将去。'盐神受而缨之。廪君即立阳石上，应青缕而射之，中盐神。盐神死，天乃大开。"

今日重庆，在朝天门码头，相依望江的恋人，依旧为那个古老传说神驰吗？美丽传说的背后，是为了寻觅幸福而做出的取舍。盐水女神为了抓住爱情而失去生命，廪君务相为了生命而放弃爱情。可歌可泣只限于神话里，现实终归是柴米油盐。

千秋过后，今日重庆，运货的棒棒军，剃头的理发师，卖旧书的小商贩，盖房的建筑工人……许多营营役役的老百姓，既务实营生，又会靠打麻将、跳舞、品茗来休闲作乐，作息有时，劳逸有序。人们同样寻觅幸福，但不必做出轰轰烈烈的取舍，简简单单就好。

滔滔江水，望江伴侣的背影，一切尽在不言中。

— 护生 —

在西宁的日子，我体会到"舐犊之情"的含义。

每当有孩子的场合，我不单看到孩子，还会看到他们身边的人，不管他们是谁，和孩子是什么关系；而从他们与孩子的互动之中，流露出人与人之间极其含蓄却深厚的情感，自然而然。这是我听不到、摸不着，只能默默地、悠悠地接收的感动。

父母家人陪同天生唇腭裂的孩子，到西宁的医院去做手术，孩子手术前后的变化，父母的种种复杂情绪，焦虑、担忧、期盼、忐忑，又岂是笔墨能形容？我看到一个蹲在地上怀抱孩子的父亲，抚摸着孩子的脸，安抚着幼小心灵，仿佛在告诉他：别怕别怕；然而身旁掩面的母亲又岂会不怕？

另外一个坐在病榻上的爸爸，同样怀抱着孩子，父子俩仰起头看着输液瓶架子上吊着的几个手折纸鹤，笑容灿烂，眼神晶亮，对于手术成功和幸福未来的热切期盼，溢于言表。手术后，孩子躺在病床上，身旁的妈妈拿着一根大羽毛，不知道是为手术后的孩子扇风，还是逗他玩，也可能是分散他的注意力，以稍减孩子身上的苦痛，也稍减母亲心头的痛。

不经意的互动，情真意切，一点一滴，涓流不息；丰子恺先生的《护生画集》里"首尾就烹"的画面，徐徐泛上心头："学士周豫家，尝烹鳝。见有鞠身向上，以首尾就烹者。讶而剖之，腹中累累有子。物类之甘心忍痛，而护惜其子如此。"

— 自在 —

在成都的日子里，我想起了巴黎的街头。

成都人手中的茶杯，巴黎人握着的咖啡杯，两种饮料，两种文化，一种态度。我姑且把它称为"大都会慢生活"。这个"慢"字，来自骨子里，浑然天成，流露在眼神、嘴角、动作、气息里。他们生活在气候宜人的天府之国，作物富足，常得温饱，不必受物竞天择之苦；不争，就不必斗快，自然就放慢脚步。慢走路，可以看得见匆匆而过时忽略的景物；慢生活，自然更能体会小日子的小趣味。

一个"逸"字，让我回想起人民公园鹤鸣茶馆的午后。沿湖摆放竹制桌椅，形形色色的茶客，独个的、成群的，疏落，随意。我感到，喝茶并不是老年人无所事事的寄托，而是一种生活的态度。紫砂碗、白瓷杯、玻璃杯，乌龙、黑茶、青茶，各有所好；聊天，打盹，读书，采耳，遛鸟，发呆，各得其宜；一个下午，不慌不忙，而贯通其中的是一种安逸悠闲的态度。

一个"静"字，是我走进文殊院的第一个感觉。这个静，不是没有声息的死寂，而是在群体里、活动中，依然得到清净、心静。人说文殊院是一个世俗关怀的寺院，没错。也许来这里的人，部分是为了进行宗教活动，其他的就是在这里过日子的，恬静的、自在的日子，不赶，不拼。

在巴黎街头，握着咖啡享受瞬间悠闲的巴黎人，总会为这个城市的气质而骄傲。我想，在茶馆里过着慢生活的成都人应该也是这样吧。

— 昭华 —

在游埠古镇的时候，我体悟到似水流年。

在浙江省兰溪市游埠古镇，纯朴的古镇居民保留了摸黑吃早茶的习惯，老茶客们喜欢长期都坐在同样的位置上，习惯变成规律，规律化为日常。某个冬日早上，早茶摊出现了一位老者，独自坐在板凳上，条桌上有一个茶杯一副眼镜，再没有其他；同样，老者的周遭，除了空桌子和空凳子，再没有其他。曾几何时，这里的光景应该不一样吧？

过去，摸黑过来吃早茶的其他人，先后坐满了围着条桌的板凳，各自坐在各自的位置，面前也搁着各自的茶杯和杂物。不知道来自何方的茶客们，也许絮絮不休地拉家长里短，也许天南地北地聊着大事人生，也许调侃、也许嘴战、也许咆哮、也许低回；一番热闹过后，人渐渐散去，各自回到各自的生活里，次日再来，如此日复日年复年……然后，茶客渐渐减少，不来了，不爱来了，不能来了，缘由无须多问。

直到某一天，老者发现他是唯一的茶客。他低头看手表，无语让时光消逝。在这个孤寂的、美丽的角落，我收获了一份厚重的感悟。

─ 心照 ─

3月，某夜，倒春寒下了两天雪，天际微微泛着暗红色，刚好有月。许多年前，在布达拉宫前，同样，刚好有月。西藏拉萨的一家盲童学校里，围绕在我身边的都是失明或有视障的大大小小的学生。我想，在这些孩子们的世界里，是否只有夜幕？而在那无始无终的夜里，是否有月？我们看得见的，他们看不见；他们看得见的，我们同样看不见。是这样吗？

在和他们相处的一段时间里，我静静窥视他们的世界，才发现原来如此丰富多姿！某个下午趁着小休，几个有视障的同学挤在宿舍的床铺上看手机，聚精会神，非常专注；看完手机马上下来就地比划，拳风掌风，你来我往，使出看家本领、武林绝学；大呼小叫，其乐无穷，郭靖、黄蓉、周伯通、欧阳锋……各自称雄，原来他们看的是金庸的武侠小说《射雕英雄传》。至此，我得到了答案，赤子之心是如此相类似；我们置身"不同的世界"，但是我们的心灵可以互通。

不知何故，盲童学校里一个特别弱小和智力偏低的有视障的孩子对我很感兴趣，从头到尾跟随我，偶尔伸手触碰一下我，我们无法以语言或文字沟通，但我感到我们的心灵有这么一个交叠的时刻。

某年在新疆喀什的一个小村庄里，不知道从哪里来了一个小男孩，站在我前面，他手拈一朵红艳的鲜花，抬到脸的高度，遮挡了他的嘴；憨憨的，男孩把花朵送给了我。然后，各自走各自的路。

在这几十年的慢游中，不管是细细观察过、尝试了解过的人们，还是萍水相逢、擦身而过的人们，我分不清他们哪里来哪里去，但是，那真实的存在和真挚的情感，丰富了我的人生，这就是我最珍惜的。

摄影师笔记

王身敦

20世纪80年代，中国改革开放的初期，我作为一个背包客，数次踏足神州大地，拍摄了很多黑白照片。后来90年代在伦敦工作与生活，手上已经积累了大量在中国以及世界各地拍摄的老底片，我常常为储存的问题发愁，总是觉得应该把底片好好筛选一遍，只保留最佳水平的，稍有疑虑的都可以放弃。就这样，我把当时觉得不太理想和有欠深度的底片扔掉了，在保留下来的为数不多的底片之中，在中国拍摄的就只剩下三四十张，也就是收集在这本影集里的那些较老一点的照片。

想当时年轻，觉得来日方长，将来大可以重临旧地，重拍那些照片。然而，后来中国的改变之巨大和迅速，完全出乎我意料，纵使重回昔日去过的地方，只觉一切都不再一样，岂止物是人非？那些曾经被我摄进镜头里的影像，已经随着被我扔掉的底片，永远消失了。我觉得这是个极大的失误，但也是一种无穷的动力。所有发生的事情都有因有果，当时的一个错误选择，让我非常懊恼，但也是这个错误，推动我日后决定留在中国长时间生活和拍摄照片。

1997年2月邓小平逝世，那个时候我是路透社亚太区的新闻图片副总编辑，我带着十多个摄影师到北京进行拍摄；西方媒体极为关注这位对中国乃至世界举足轻重的人物的辞世，以及之后中国的变化及对于全世界的影响。拍摄中，看到中国在短短十多年间的许多改变，我非常好奇，所以在1998年我决定去中国，不管是拍摄，还是体验，我希望见证中国的改革开放。

2008年我结束了为通讯社及图片社工作的岁月，当上了独立摄影师。没有了日常工作和庶务的羁绊，我完全掌控时间与步伐，开始慢慢地游走在中国的大地上；无论在慢游途中屐痕何处，我想看的始终是百姓的生活，想体会的始终是人与人之间的感情。

与其把"慢游中国"当成一个摄影项目，我更倾向于将其作为生活的一部分。《慢游中国：只道寻常》里的影像全部都是在纯自然的情况下记录下来的，我只是一个旁观者、一个聆听者，我要看的是中国一般老百姓真实的情感与过日子的情况；我完全没有尝试去影响被我记录拍摄的人与物，乃至氛围。

《慢游中国：只道寻常》里使用的两台照相机都已经跟随我很长时间了，绝大多数时使用的是 35mm 和 50mm 镜头；黑白胶卷是我这近 40 年来一直使用的，型号为柯达 Tri-X 400。我运用少量手动器材和熟悉特性的胶片，这样使我在拍摄记录时头脑更清澈，可以更专注于感受我面前的人与物；同时，黑白照片脱离了色彩的影响，可以更聚焦于情感与信息的传递。《慢游中国：只道寻常》中的照片都是全画幅输出，并没有进行第二次剪裁，我希望读者看到的，就是我拍摄时在取景器里看到的影像。

编辑手记

杨磊 / 文

找到一个平静的状态，走进和理解王身敦的作品，是编辑这本作品集的第一步。

王身敦是那种很传统的愿意把自己隐藏起来，只用作品表达的摄影师。他敏感、专注、低调，安静地做着一个记录者和聆听者。他之前在全世界顶尖的新闻通讯社做图片编辑、摄影师、副总编辑，其间还当了两次荷赛的评委和共18年（2000—2018）世界新闻摄影大师班的提名人——这些"光环"给人的想象是，他的作品应该是"极具冲击力"的"视觉盛宴"，但事实上，他耗费近40年拍摄的个人专题"慢游中国"里的那些黑白银盐影像，宁静、深邃得如同贝加尔湖的水面，才是他的作品。

一线新闻通讯社的时效性、作品的震撼性与他真正为自己拍摄的作品存在着巨大的反差，而这反差中所浓缩和蕴含的正是做这本作品集的理由：久违的、日常的阳光和空气带给我们的真实触感；从他人的生活和心灵中我们能够体会到的一切——无尽的远方，无数的人们，所有人的幸福，都与他人有关。

当"日常"变为一种渴望

那一张张各具表情的面孔，一些充满了故事的场景，一些主人公与土地的联系，一些贯穿历史的风俗，一些相互呼应的空间关系中发生的情感，像在画廊里漫步，更像进入了一部纪录片。在抽离了色彩的黑白空间中，有空气，有风，有雨水，有冷暖，有味觉，有触感，有情绪。当我去主动感受他人的生活时，就能感受照片里的空气。这一切，也许在以往不算什么，但在全球疫情肆虐的环境中，显得尤为珍贵。这样的客观环境提醒我们，"日常"也许是最珍贵的，也是最容易被人们忽略的。日常的价值就是如此。这本作品集不需要有那种极强的主题性、符号性、风格性。相反，我们要做的正是去掉这些标签，连摄影师都退居幕后，取而代之的是让照片本身说话，用生活本身去阐释生活。

这是很好的阅读方式，不仅仅是阅读图书，阅读作品，还是放下杂念，去慢慢地游走，遵从和打开自己的内心，去看，去读，去感受，去寻找——什么关系和情感，能让摄影师按下快门。读者会从照片里、日常生活里阅读属于他们的真实生活。

这是一本"纯粹"的摄影画册

可以说，"慢游中国"专题本身是很纯粹的艺术品——摄影师拍摄时间跨度很长，关注点很集中，随着年龄的增长、阅历的增加，王身敦对于这个题材的理解也在不断地深化，能力也随之增强，但是他并没有去开辟新的题材或去做别的事情，而是继续全身心投入这个项目后续的拍摄中。在现代社会这个大环境中，摄影师能保持这样的专注度、行为方式和定力是难能可贵的。所以这本画册是"摄影师的画册、读者的画册"，是摄影师用几十年给读者带来的叙事诗，而不是我们在网络世界、电商世界中已经习以为常的"以用户为中心，注重读者体验"的画册。在我们所处的这个时代，也许非常缺乏这样的"牺牲的毅力"和"对于纯粹的信心"。

"纯粹"的另一个体现是在器材上及排版方面。王身敦为了保持视觉的一致性，近40年来只用一种胶片（柯达 Tri-X 400），一种旁轴相机（徕卡 M6），35mm 和 50mm 两支镜头，来拍摄这个专题——黑白胶片银盐颗粒的密度感和厚度感，是连贯的、自然的。排版方面，照片全部一样大，位置一致，就如同在纸上美术馆进行展览。页码和图注不会干扰读者对图片的阅读，图注都放在书的最后，全书简洁，保持足够的留白。它的全部设计语言都在对你说："别急，慢慢翻阅吧。"

视角与剪裁

这本画册里面的每一张黑白胶片拍摄的照片都是没有经过剪裁的，每张照片还保留着很细的黑边。这个黑边，是 35mm 胶片的边缘，是取景框的边缘，同时也是镜头后面那颗有思想的头和眼睛观察范围的边缘——凡是他在取景框里面看到的，就让你都看到。这是一个摄影师的执念，对于光学取景器的执念。导演维姆·文德斯在《一次》里，将镜头的力一分为二：镜头指向前面的叫作射击力，镜头指向后面的叫作后坐力。那么从王身敦的照片里面可以看出他按下快门的理由，这是一个乐趣和学习方法——是什么样的力量促使他在一个场景中拍下照片的。对于王身敦同时也对于观众而言，这也就是"拍摄瞬间的后坐力"。

他对于空间和透视非常敏感，用画面中的元素来构建了一个相互产生关系但又保持独立的视觉世界。我也能够看出多年的新闻摄影、报道摄影经历在纪实摄影中对于摄影师的影响和塑造——拍摄题材虽朴实，却可见深厚功力。

王身敦在中国香港出生，早年给合众社做摄影师，之后在伦敦生活，在路透社先后担任首席摄影师及亚太地区图片副总编等职位。20世纪80年代来到中国大陆旅游，那时候是以一种游客的视角在拍摄。但是随着他之后在北京扎下了根，生活了20多年，游历全国拍照片，拍摄公益项目，他的视角已经和当初产生了巨大差别，用他的话说："从1983年到1988年，在这片土地上，我是游客；从2009年到2022年，我是居民，我喜欢慢慢地游走在这片土地上。"从他的视角由外而内的转变中、从拍摄对象的变化中我们同样能看到历史。这个专题的跨度有将近40年，这里面一点点的改变和人们的状态的一点一滴的变化，最终汇聚成历史的洪流。

以上就是我策划本书的心路历程，希望对于读者理解摄影师的作品有所帮助。王身敦说："心里的镜子需要常常打磨，才能看清这个世界。"这本书也许就是一个磨刀石，正在耐心等待着有心人的到来。

Introduction

Liu Heung Shing

Pulitzer Prize winner
former Associated Press chief photographer for China
founding director of the Shanghai Center of Photography (SCoP)

I have known Andrew Wong since 1980s; at first, when we worked in competing Western news agencies, him at Reuters, and me at the Associated Press. Then, since both of us retired from our day jobs to pursue various independent projects, we have also had occasion to work together, occasions I value for I have long been an admirer of Andrew's approach to photography and the diligence he brings to his practice and process.

One could describe the individual merits of the works presented here, which are varied as the subjects and places he depicts. But they all share one common quality. Taken together in this extraordinary book of photographs, readers will foremost appreciate the deep sensitivity of these thoughtful frames. These show scenes from the daily life of people living in regions far from the familiar metropolises of Beijing, or Shanghai. They point to the deeply ingrained habits of and attitudes towards daily routines that are clearly changing in ways that are both cosmetic and substantive. Yet, the photographs also show activities that surprise with their easy familiarity. This a commonality of emotional timbre that we recognize and share, and which unsettles the notion of uniqueness is usually implied by such emblems of tradition and specific cultural designation which Andrew also shows. While there is nearly a 30-year gap between his early photos from the 1980s and those which follow after 2010 from his work as an independent photographer, he has a knack for seeing those instants that give true expression to a moment in time.

Even as a photojournalist, Andrew approached his work with peerless patience. Latterly, on his own time, he has invested a great deal of time surveying the landscape of daily life, as characterized by the people who bring their energy to keeping that engine humming. For all that change is unfolding and the pace of life increased, Andrew often frames incidental moments, images always uncropped, and that give a sense of stillness or pause to the endless motion. I would call this an "Unhurried Portrait of China." It's worth noting because, as the captions to the photos denote, Andrew has travelled to some of the most densely populated areas of China

– in Sichuan, for example – and, yet, he managed to find a sense of quietude and peace among its inhabitants. What Andrew sees are communities still in the process of catching up, yet not overly eager to relinquish all their habits and routines. That notion of catching up is a trope of globalization, and while the daily economies of these places could make use of modern opportunities, what these photographs show is that people get the best out of life when they do things their own way, at their own pace. It is a great accomplishment to depict such feelings across such a range of subjects and localities. With *China Adagio* Andrew achieves a deeply sensitive portrait of ordinary people.

Preface

Andrew S.T. Wong

In the span of nearly forty years, I have toured, worked and lived in this vast country. Since my first visit in the 1980s travelling as a young man, I have - over the course of more than three decades - become a long-time resident. Over the years, I have gradually travelled throughout this ancient land, encountered different cultures, met countless people and heard their stories.

Every single person I meet has their own unique story, their own unique experiences. I meet ordinary people as they go about their daily routines on street corners or quiet riverbanks, in busy markets and train stations, even in classrooms.

I capture their everyday actions from the mundane to the unusual - focusing in on the subtleties and inconsequential gestures that unconsciously illustrate the unique identity of every each person: their culture, histories and current situation.

I place my focus on ordinary, everyday people. I often find myself observing, questioning. Where have they come from? Where are they going? How have they been shaped by their past, their present and future aspirations? In the process of observation I find myself picking up on their place in their respective communities, their shared culture and histories. It is within this process that I find the most fascinating and rewarding stories.

— Promises —

When I was photographing in Chongqing, I came across an ancient folk tale that can trace it's origin back to the Ba tribe - the ancestors of modern-day Chongqing locals.

As the legend goes, upon assuming leadership of the Ba tribe Ba Wuxiang gathered his people and led them on an ambitious maritime journey in search of new land to settle on. On the course of this journey

Wuxiang and his subjects happened upon Yanyang, a land of abundance and plenty. The Goddess of Yanyang soon fell deeply in love with Wuxiang and demanded that he and his men end their quest and settle in the city - a demand that Wuxiang refused to accede to. To force him to stay, the Goddess spent the night with Wuxiang, then turned into a moth at sunrise. On their leader's command, all of the women in Yanyang turned into moths during the daytime and worked together to form a barrier in the sky to block out the sky. In doing so, the Goddess succeeded in her goal: Wuxiang and his men were forced to stay in the pitch black city as they were unable to set sail.

After being stranded in Yanyang for many days, Wuxiang came up with a plan of his own: he presented the Goddess with a beautiful blue ribbon as a symbol of their eternal love, beseeching her to wear it for as long as their love lasted. Ecstatically, the Goddess agreed.

The very next morning Wuxiang armed himself with a bow and arrow, climbed to the top of a nearby mountain and searched out the Goddess: one moth amongst many trailing a blue ribbon behind it. Finally spying her, he drew his bow. His aim was true and the Goddess, mortally wounded, fell to the earth. Her horrified subjects immediately dispersed, finally letting the sunlight through. Seizing their chance, Wuxiang and his men immediately put their boats to sea, embarking once again on their quest for the right place to settle.

In modern-day Chongqing, people of all walks of life go about their business, caught up in the hustle and bustle of one of the biggest cities in China. I wonder if the construction workers, hair-dressers, dress-makers, businessmen and families of Chongqing ever recall the ancient folk tale of Ba Wuxiang and the Goddess. Perhaps they're too busy with their everyday lives to think about it. Or maybe they don't know it at all. But I'd like to think that the couples by the river at Chaotianmen Dock along the Jialing River still do, and are still enchanted by the legend.

— Cherish —

When children are my central focus, I can't help but notice on the adults that surround them as well. There is a thread that connects a child to the adults around them - one which allows for a depth of understanding underpinned by the innocence of the subject. It is an invisible connection that I can neither see, hear, or physically feel but one that I can intuit through their actions and gazes.

When I photographed children with cleft lips being prepared for correctional surgery in Xining, Qinghai Province I found myself drawn to the emotions of the parents. In their demeanour I saw anxiousness, pressure, hope, powerlessness - on their faces sadness and a trace of anger.

Walking through the hospital, I see a mother and father cradling their child, expressing through their gestures - "be brave, don't be scared". Not far away, I see delighted children testing their new smiles for the first time, happiness emanating from their whole faces. In another room, I notice a father holding his young child, their eyes sparkling in anticipation - the operation is not far away now. Above their heads are folded paper cranes, a symbol for hope and healing. Sat on his father's lap, the child reaches for the nearest crane: his fingers are just close enough to graze it.

Renowned illustrator Feng Zikai celebrated the life of his Buddhist master Hong Yi by drawing a dedicated illustration for him on the day of his master's birthday. These were later collected in the "Hu Sheng" illustration series - with "Hu Sheng" meaning the protection and cherishing of all life. One of these illustrations shows scholar Zhou Yu cooking an eel in an earthenware pot. To his surprise, the eel contorted its body into a bridge - with its head and tail immersed in the boiling water, leaving its body out of harm's way. Mystified, Zhou cut the eel open to find eggs inside its ovary. Touched and saddened by the lengths that even a fish would go to protect its offspring - Zhou found himself ruminating on the sacrifices that a parent would make to spare their children from pain.

— Ease —

Walking through Chengdu - in Sichuan Province - always makes me think of the streets of Paris.

Tea culture in Chengdu is not dissimilar to Parisian coffee culture: despite being situated in very different countries certain similarities can be found - an emphasis by the inhabitants of both cities on taking the time to be unhurried and mindful in the midst of the bustling city. Sichuan Province is renowned through China for its climate, natural resources and fertile soil. A long history of abundance has perhaps led to a more unhurried pace of life in cities like Chengdu: a slower pace of life seems to have been passed down over generations.

When I think of Chengdu I always recall the traditional teahouses scattered around the city. I observed locals spending their afternoons around bamboo tables leisurely drinking different kinds of tea from a plethora

of different cups - purple clay, porcelain and glass - as the fragrance of Oolong, Longjing and Tieguanyin wafted through the air. Songbirds in portable cages are often brought in by older gentlemen, and they look on as a typical afternoon at the teahouse unfolds: locals stop by to catch up, read, chat, paint calligraphy or just idle for a while before they carry on with their day.

Rather fittingly, Chengdu is also home to the Manjusri Monastery, dedicated to the Bodhisattva of wisdom. Though impassively still and tranquil, the Monastery is not simply a solemn place of worship. In fact monks and local residents often co-mingle and interact with an ease befitting the city it's situated in: the monastery is as much of a refuge for the secular as it is for the religious. It is outside the monastery itself that I notice two locals burning joss sticks and making offerings to their ancestors, their figures dimly lit by the glow of a streetlamp above them.

— Being —

Like the visitors to teahouses in Chengdu, residents in the old town Youbu of Lanxi in Zhejiang Province have integrated their favourite spots into their daily routines.

Breakfast is an early affair in Youbu: each customer takes their regular spot outside the teahouse, orders their usual and catches up with their friends and neighbours. As the morning goes by, many different groups of regulars pop in, coming and going with a pleasing regularity. Every morning without fail, the same faces show up and the routine repeats itself again: another start to the day spent at the teahouse.

But the comfort of this routine is no match for time itself: stopping at the teahouse there one morning I notice an elderly man sitting alone with a cup of tea and his glasses in front of him at a large table. As he squints to check his watch I wonder if he's thinking about the passage of time as well. Was he once surrounded by friends at this table in decades gone by? Could he be thinking about his large group slowly dwindling in numbers, their lively morning conversation getting quieter and quieter over time? Did this shrinking group eventually start mentioning friends in the past tense - with every morning's cup of tea serving as a reminder of them? Today though, he'll wait a bit longer at the teahouse - maybe someone will show up a little later.

— Luminance —

As I sat down to write this, I saw that the skies in Beijing were an atmospheric dark red, with the moon high in the sky: even as late as March it is a sure sign of snow. This brought me back to Lhasa, where many years ago the Potala Palace was illuminated by a similar sky, with the moon hung high above me. I was in Tibet to visit a school for the blind, where I spent a week with the students there. Travelling there, I wondered how their world differed from ours. I gradually came to understand that there were many more similarities than differences between us.

One day, during their lunch break, I came across a group of partially sighted students intently studying a video on one of their phones. Once the video had finished, they sprung into action: they immediately started leaping, doing martial arts poses, jumping around their room excitedly calling back and forth to each other in a native dialect that I unfortunately did not understand. Even so, it wasn't long before I realised that they were playing characters from Jin Yong's famous martial-arts novel "Legends of the Condor Heroes" - just like my friends and I did when we were children! The power of imagination and the inspiring power of storytelling is something all of us share.

Over my years photographing China I have crossed paths with children from many different kinds of backgrounds. They have inspired me to question my own worldview, to place myself in their shoes and to try to tell their stories via my medium. Later on in the week, I met a developmentally impaired student at the school for the blind. He followed me around hesitantly, occasionally reaching out to touch my hand, to rub my jacket, and run his fingers along my photographic equipment. Unable to communicate with him, I can only speculate that he was fascinated with a stranger he had never met before, and was communicating with me in his own way, through touch.

In Kashi of Xinjiang Uygur Autonomous Region, I was startled by a boy who appeared, as if from nowhere, in front of me clutching a vibrant red flower. He stood there in silence staring up into my eyes for a couple seconds, before he humbly presented me with the flower. I accepted his beautiful gift with gratitude. Having presented the flower to me, he silently turned and walked away. The red flower soon wilted and withered, but the boy's steady gaze and shy smile will stay with me for a long time.

I have cherished my nearly four decades of travelling and photographing in China. Regardless of whether they are planned trips with an itinerary or free flowing journeys with all the unexpected turns that this entails, my photographic life will continue in the tempo of adagio. It is in telling the stories of the people I meet through my photographs that I am most fulfilled - and I will continue to do so in the years to come.

Photographer's Notes

Andrew S.T. Wong

When China opened itself up in the 1980s, I undertook several trips as a backpacker there, where I photographed the country in black and white. Later on in the 90s, I worked at the Reuters News Agency headquarters in London. By then, I realised that I had accumulated a large number of negatives from both China and the rest of the world. I struggled to store and preserve all of them in my small London home, and so I made the decision to screen them all, only keeping the negatives that I considered to be perfect images. I ended up disposing of most of the negatives in my possession - only retaining around 30 to 40 of the best photographs from that time. In turn, I have selected the strongest images out of those. These are the early photographs showcased in this book.

When I think back to the decision that I made back then I am struck by my naiveté. My thinking as a young man was that I would simply return to China at a later date to re-capture these imperfect images, aided by the experience and skill I would gain over the interceding years. However, I failed to anticipate the speed and intensity of China's development. By the time I returned, the country I had captured in my youth had changed drastically - my record of that time had disappeared with the negatives that I had disposed of. Throwing away the majority of my negatives in London was a huge mistake that I regret, but one which has motivated me to make up for this loss as best as I can.

In February 1997, in my capacity as deputy news pictures editor of Reuters Asia I brought over 10 agency photographers to Beijing to cover the death of Deng Xiaoping. Western media was extremely interested in this story: the death of one of the most prominent Chinese political leaders, China's changes post-Deng and it's wider impact on the world. Returning to the country for the first time in just under a decade, I found it fascinating how much had changed in China since I had last been. Wanting to be a first-person witness to the latest reforms in China's history, I soon relocated to Beijing.

In 2008 I left the world of news photography and decided to become an independent photographer. After decades of regimentation I found myself with the time and freedom to photograph slowly, with no set destination and no deadlines. So I started travelling all around China, taking my time to understand the places and people that I came across.

I consider *China Adagio* to be more of a way of life than a photographic project. I consider myself a spectator in the scenes that I capture. What I attempt to capture through my viewfinder is a direct translation of what is happening in front of me with as little of my personal input as possible. It is my goal to simply capture moments from everyday life as I travel.

The two cameras I have used in *China Adagio* are my long-time companions - I have used them for decades. Most photos in this collection were taken with 35mm and 50mm lenses. The film I use is Kodak Tri-X 400 - a black and white film that I have used for nearly 40 years. I prefer a fairly minimalist, simple setup so that I can focus better on the world around me. This is also the reason why I have chosen to shoot exclusively in black and white - the images that I capture can better convey the message of affection in life, free from possible distractions brought upon by a vibrant colour palette. All pictures in this book are full-frame and uncropped. Readers are thus able to see exactly what I saw in my viewfinder, and visualise the scene exactly as I did.

Editor's Notes

Yang Lei

The first thing I needed to do when I first started the process of editing this collection was to enter the right state of mind: calmness is key for entering Andrew's photographic world.

Andrew Wong is a photographer who would rather let his work do the talking. A sensitive and focused photographer, he prefers to listen and observe. Before becoming an independent photographer, Andrew worked for major news and photo agencies for about three decades. He was a jury member for World Press Photo in 1998 and 2003, and was a member of the World Press Photo Joop Swart Masterclass Nomination Committee from 2000 to 2018.

Perhaps you would expect to see symbolic or controversial images from a veteran news photographer, but Andrew's *China Adagio* photographs are calm and tranquil - bringing to mind the depth and stillness of Lake Baikal. When I release myself from the disruption of daily life and allow myself to take in his collection of black and white pictures, I come to realisation that ordinary people and the little things in life can be as powerful and insightful as photographs taken in more dramatic circumstances. Light, air, nature, children, the elderly, men, women, little looks and touches, smiles, fears, feelings and emotions can often be taken for granted or forgotten. In Andrew's images, they suddenly take centre stage.

When "everyday life" becomes a longing

In these images we see faces with different expression, scenes full of stories, some featuring the subject's connection with the land, some featuring historical customs, some featuring spacial relationships that mirror each other. It is like walking in a gallery, like entering a documentary. In the black and white space devoid of the distraction of colour, there is air, wind and rain. There is cold, warmth, taste and touch. When I take the initiative in feeling the lives of others, I find myself able to really feel the atmosphere of their setting.

All of these ordinary moments may have been just that - ordinary - in the days gone by, but they are particularly precious in the context of the Covid-19 global pandemic. Such an objective environment reminds us that the 'everyday' is perhaps the most precious and the most easily overlooked. That's what everyday values are. As such, this book perhaps doesn't need to have a strong, overarching theme, symbolism or style. Instead, it is in the absence of such overarching themes, symbolisms or styles that *China Adagio* flourishes: the photographer retreats into the background, instead allowing the images speak for themselves, using life to illustrate life. The best way to read this book is to let go of distractions, to move slowly and open your heart. To see, to read, to feel and to find - and then, finally to understand - what mix of relationships and emotions made the photographer click the shutter.

This is a "pure" photographic album

It can be said that the adagio tempo of this project is in itself a pure work of art - the photographer shoots throughout a very long time frame with a very concentrated focus. With age and experience Andrew's understanding of art as life also deepens. Andrew does not use his increasing abilities to open up new subjects and topics, but instead uses it to deepen his area of focus. Therefore, *China Adagio* is a "photographer's photo-book" as well as a "reader's photo-book". It is a narrative poem that the photographer has slowly written over decades, rather than a photo-book focused on instant gratification and quick results.

Another manifestation of preservation is in terms of technology and printing. All images in this book are shot with Kodak Tri-X400 film, and two Leica M6 rangefinder cameras, using two lenses - 35mm and 50mm in a time span of nearly 40 years. The sense of density and characteristic grain on the Tri-X black and white film he uses adds to a sense of naturalness. In terms of typography, the photos are uniform in size and consistently positioned, like an art museum exhibition on paper. The page numbers and illustrations do not interfere with the reader's enjoyment of the pictures. Captions are placed at the end of the book, and the entire book's design scheme is simple and sufficiently spacious. It is as though *China Adagio's* design language is telling the reader to take their time over the book.

Editing and Perspectives

All pictures in this book are full frame output without any cropping. The thin black edge surrounding each picture is the edge of the film and the viewfinder, an inference that whatever Andrew sees in the viewfinder is what the reader can see - nothing less and nothing more. In "Once", director and photographer Wim Wenders divides the power of the lens in two: the camera pointing forwards is shooting, the camera pointing backwards is recoil. So for Andrew, the reasoning for capturing each image is hidden inside the work itself. He is extremely sensitive to space and perspective, utilising different elements in each picture to construct related visual worlds, but which are also standalone images. The influence of reportage and photojournalism can be observed in his work - though his subject matters are often simple, one can see an insistence on being as truthful to the subject matter as possible through his approach.

Andrew Wong was born in Hong Kong, where he started his career as a photographer for United Press International. He then worked for Reuters, where he was based in London, Hong Kong, and Singapore before moving to Beijing in 1998. In his own words, "*In the span of nearly forty years… I have gradually travelled throughout this ancient land, encountered different cultures, met countless people and heard their stories.*" Andrew has transformed himself from an outsider visiting China in the 1980s to a long-term resident, offering varying yet unique perspectives with a polished mirror in his heart to reflect the affection in life.

I hope my notes will provide some guidance to help readers to approach Andrew's work. Now it is time to venture into the photographer's world, in an unhurried pace of adagio.

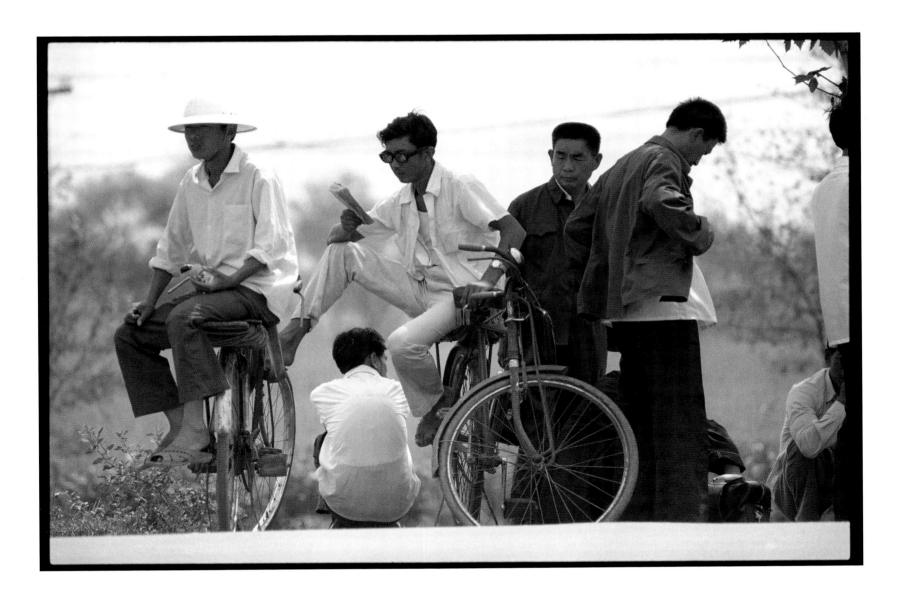

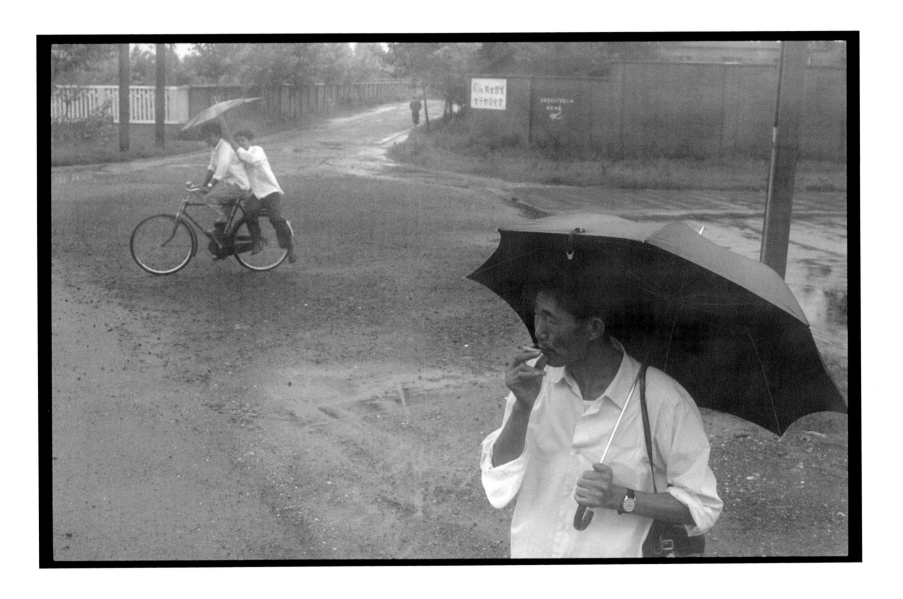

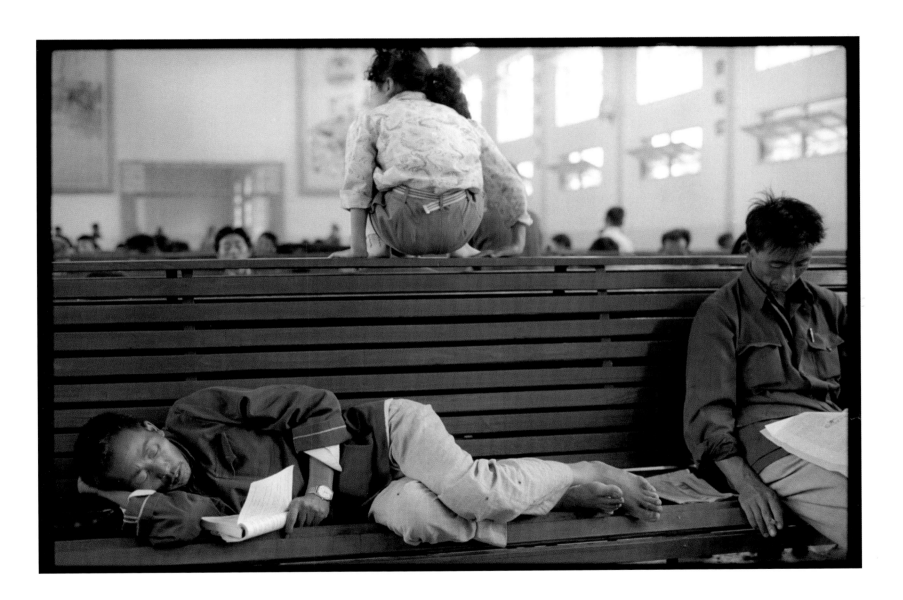

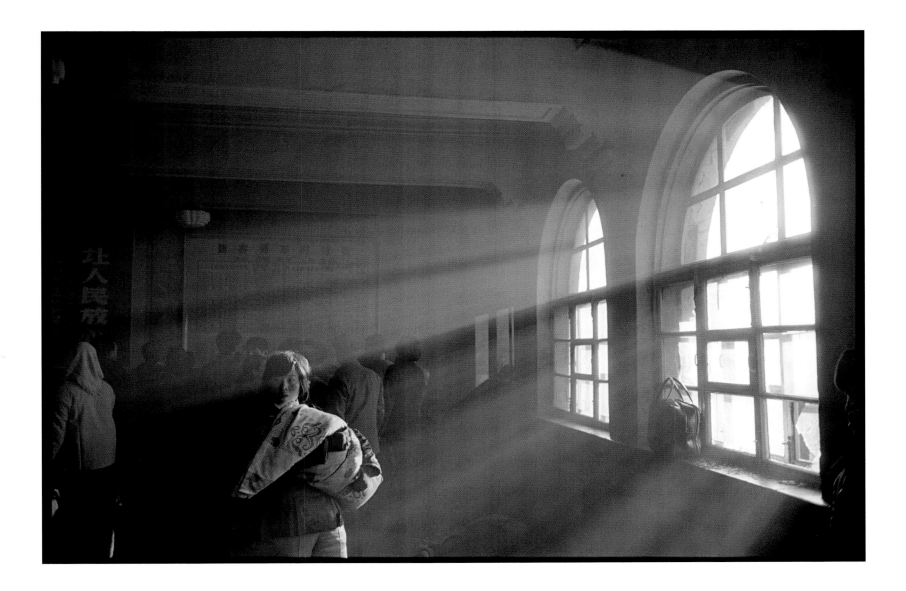

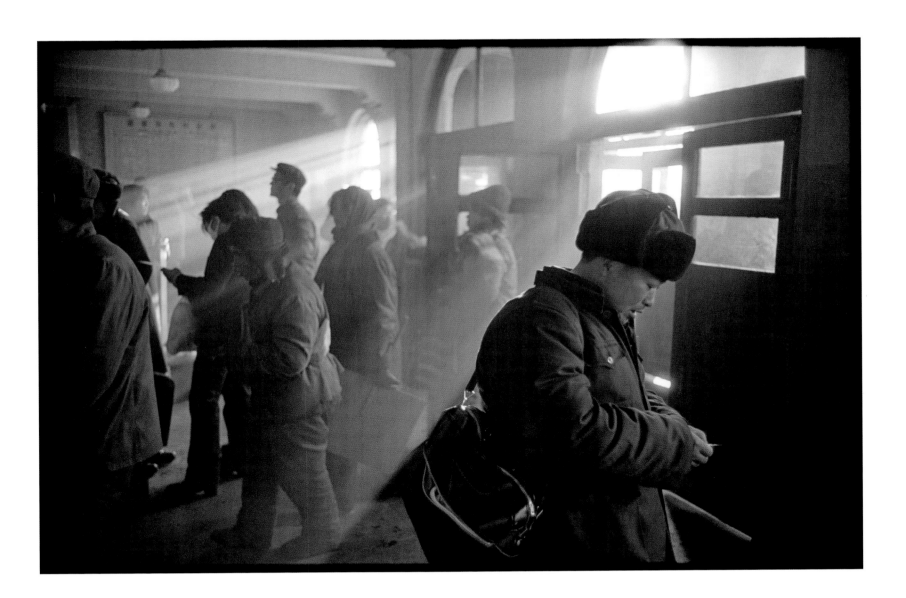

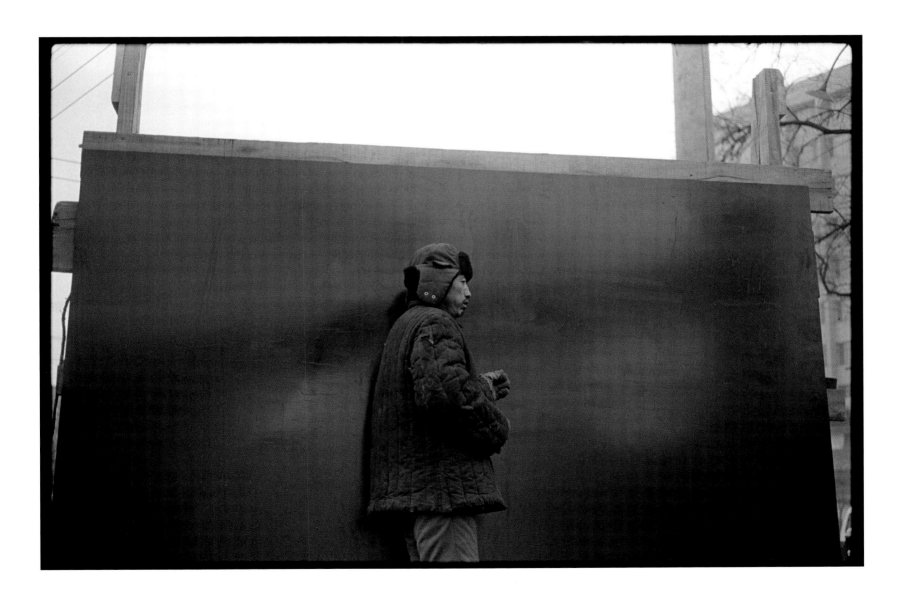

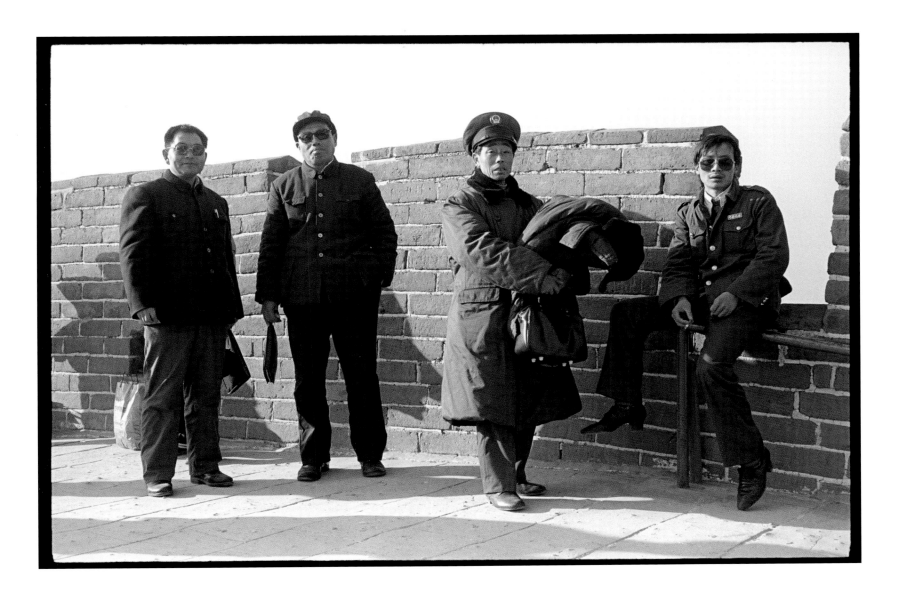

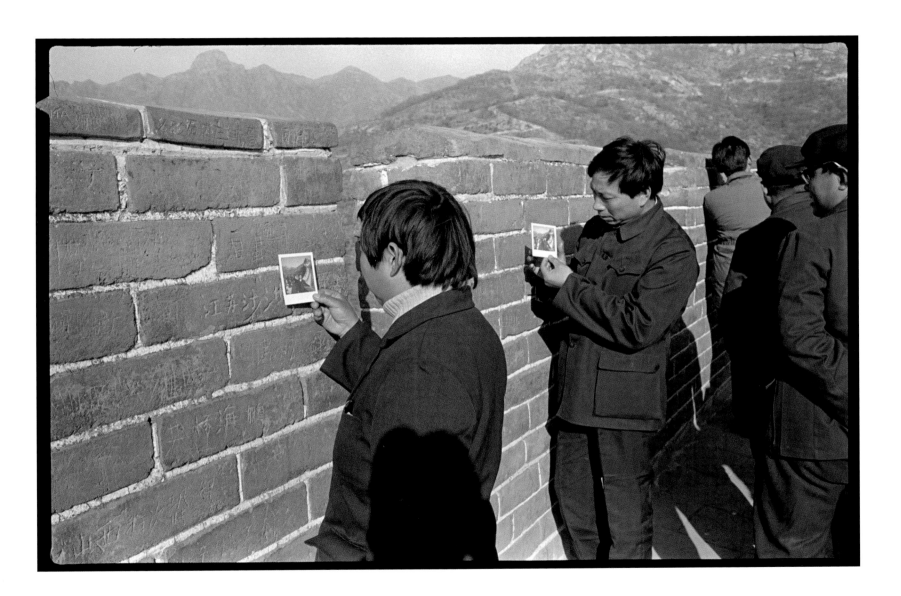

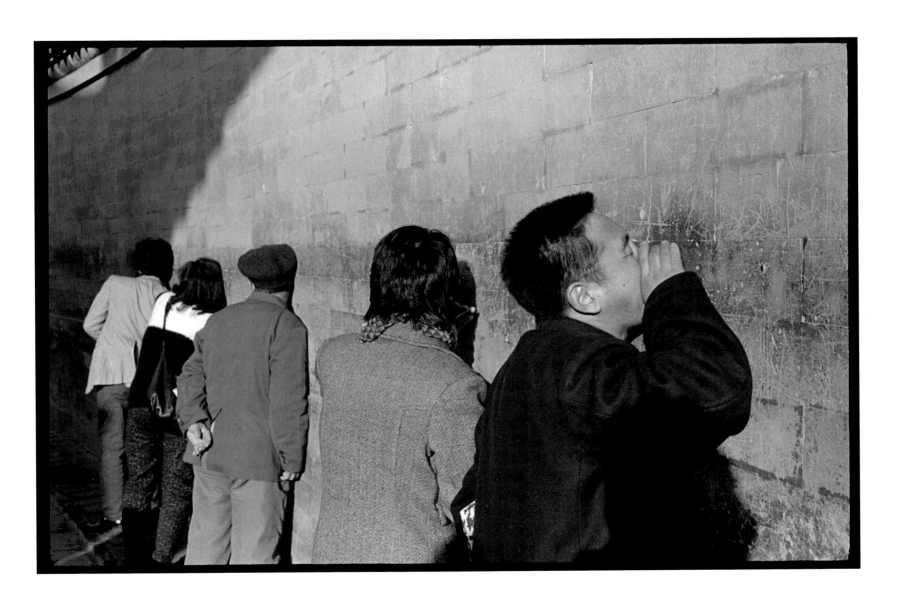

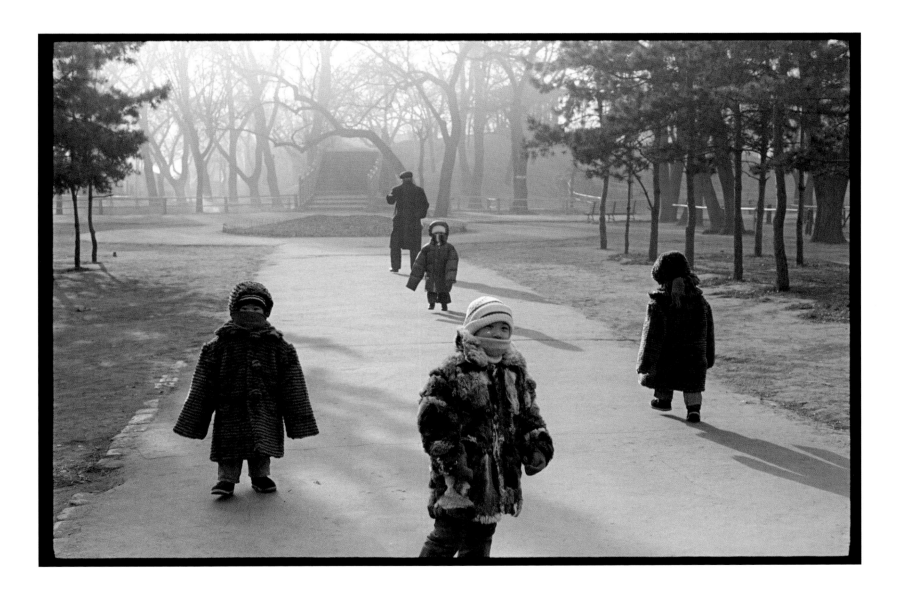

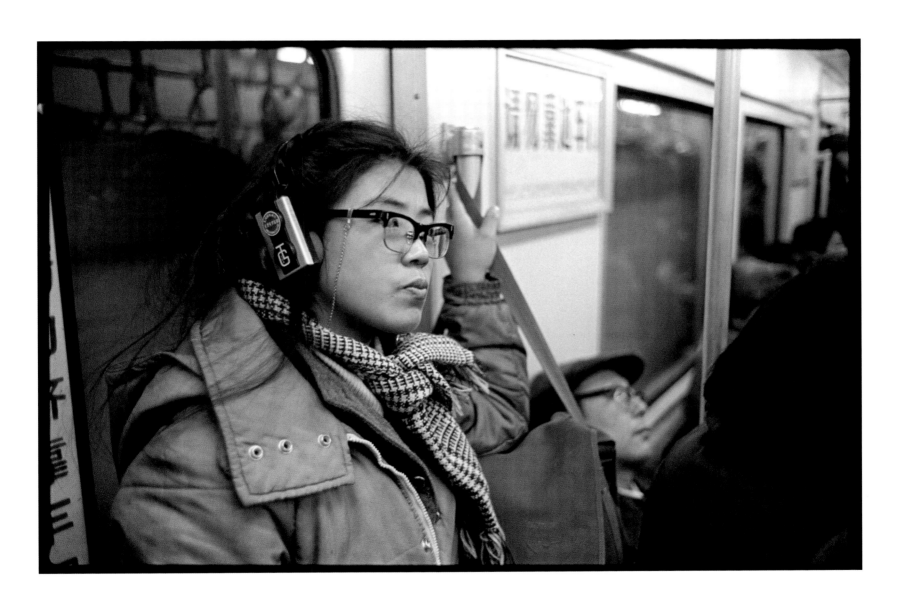

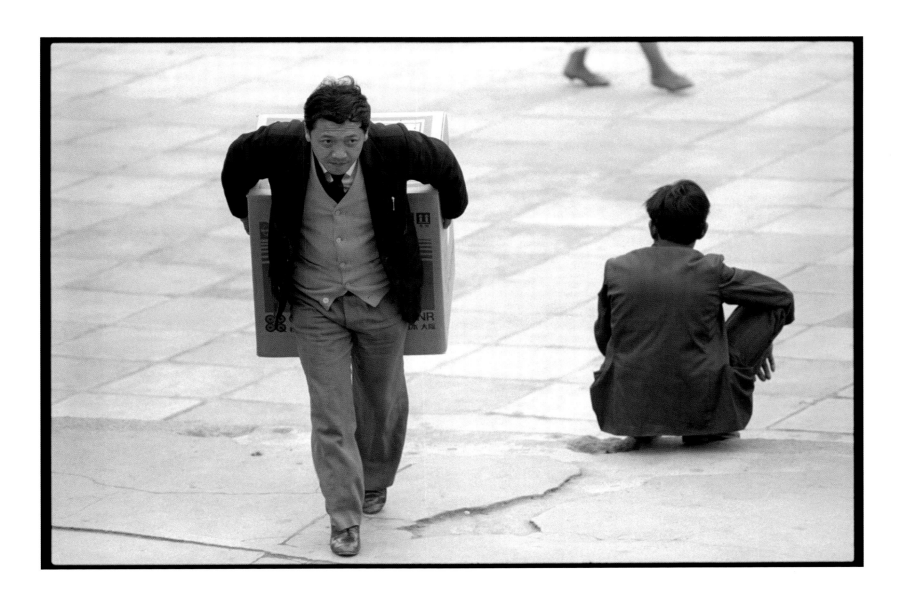

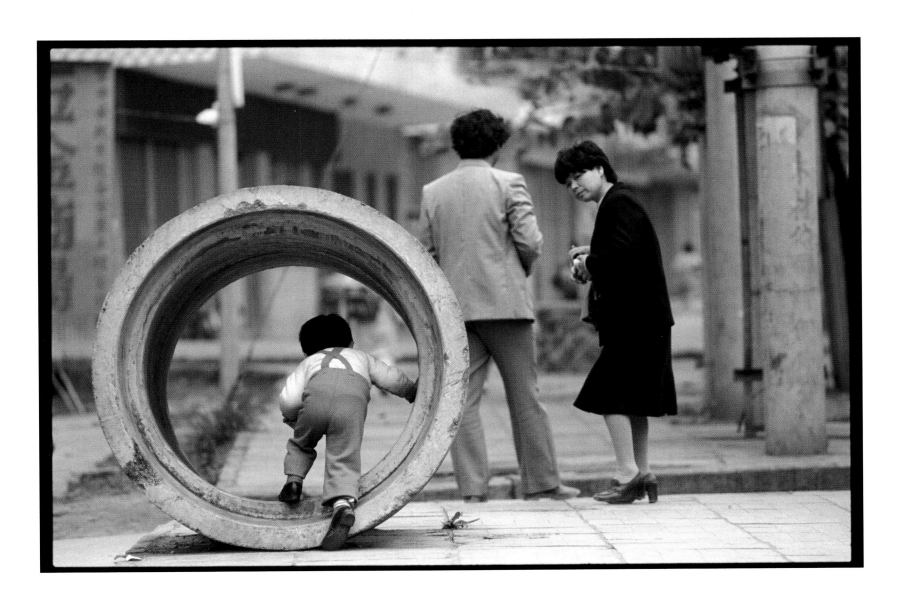

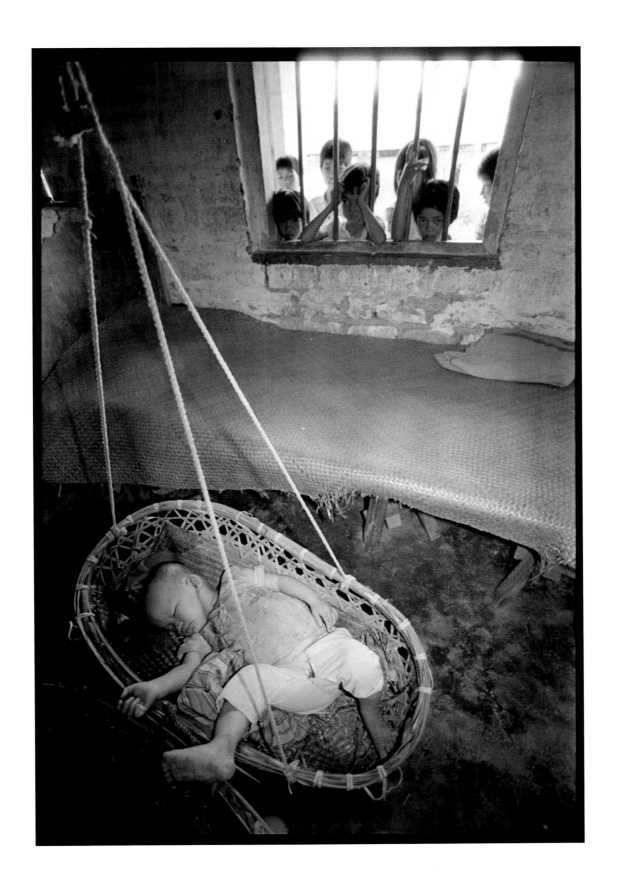

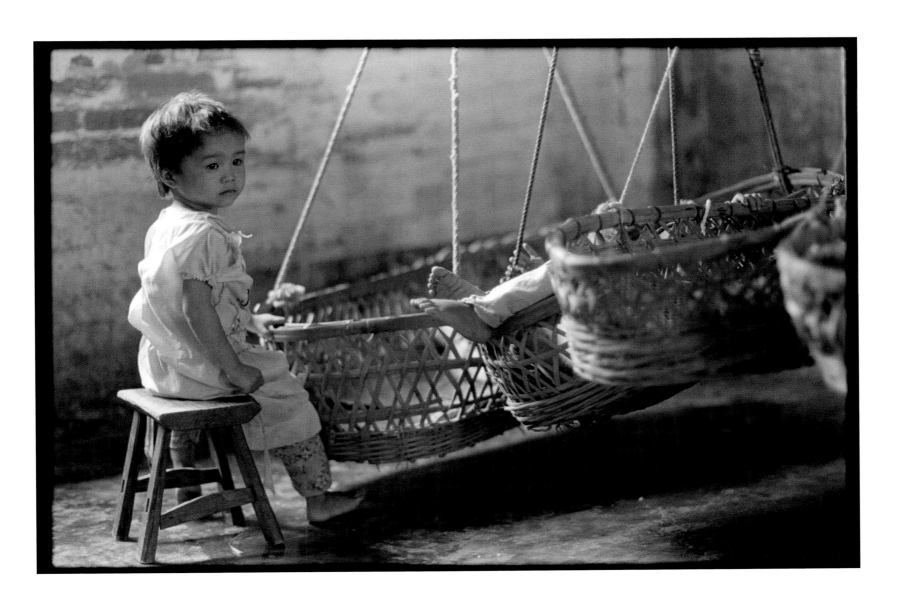

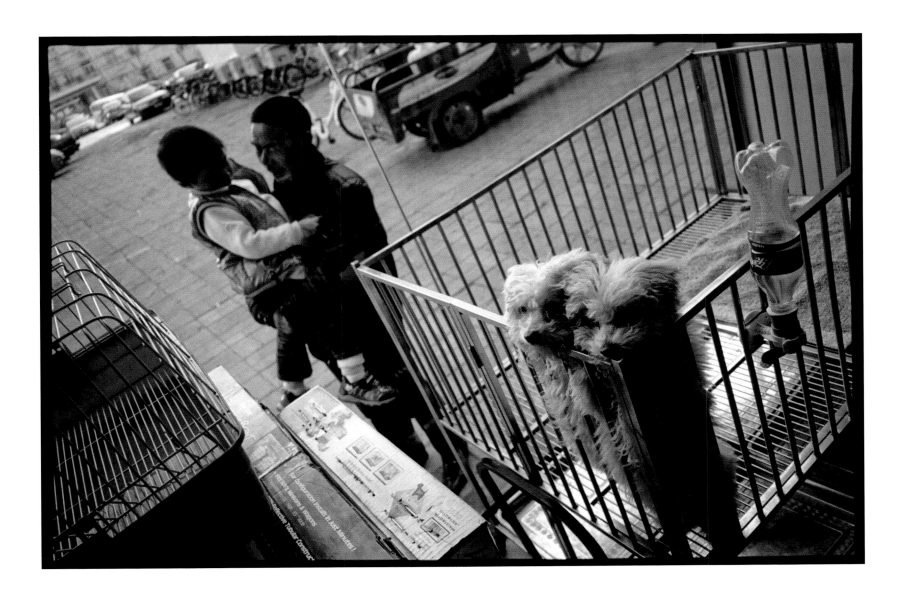

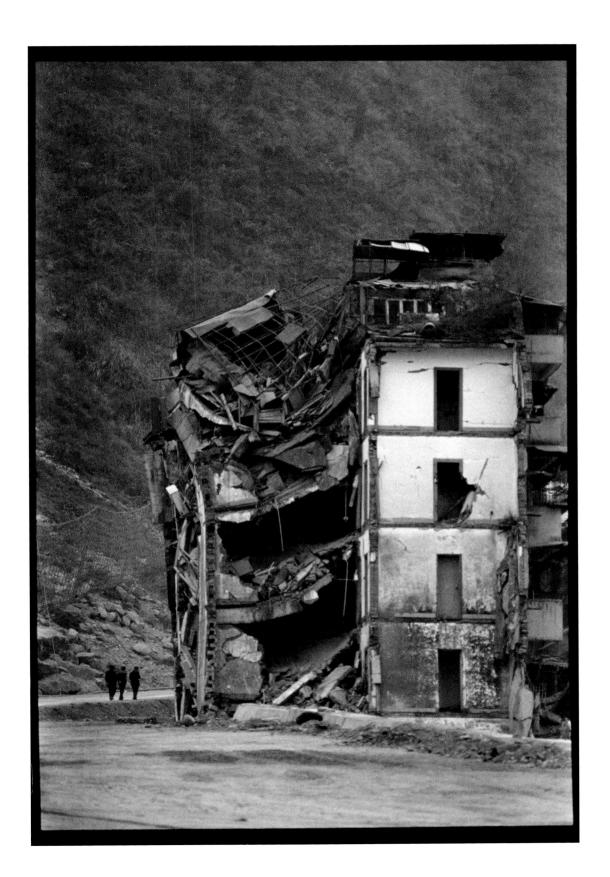

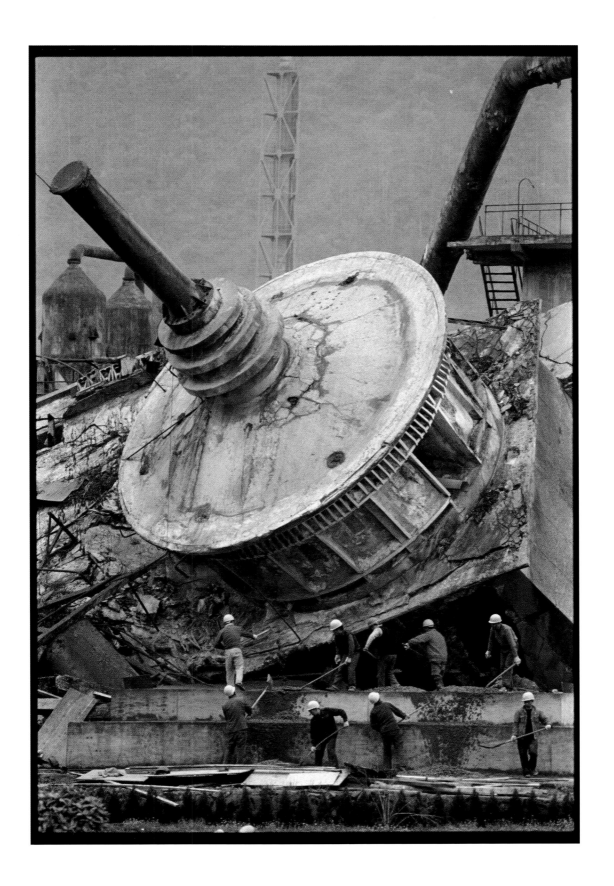

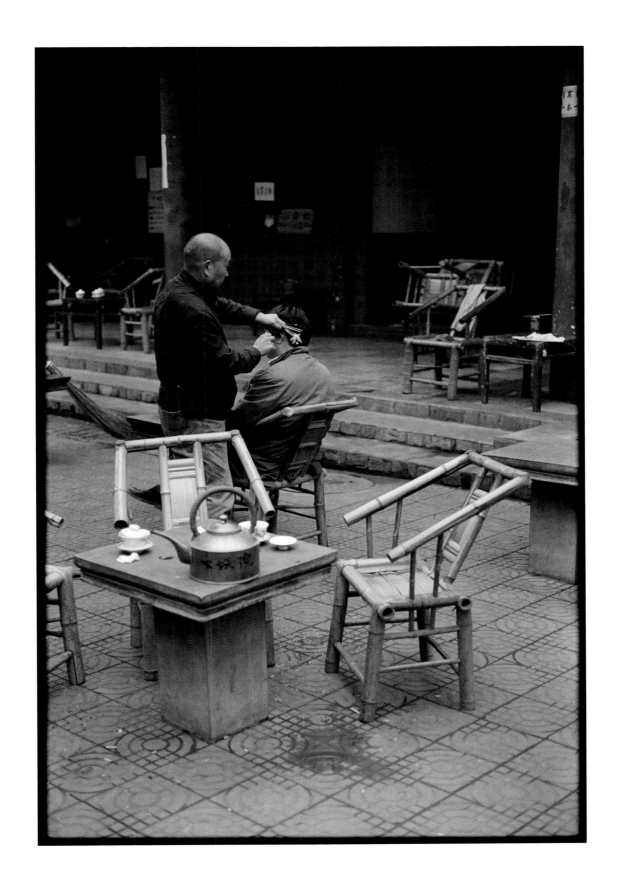

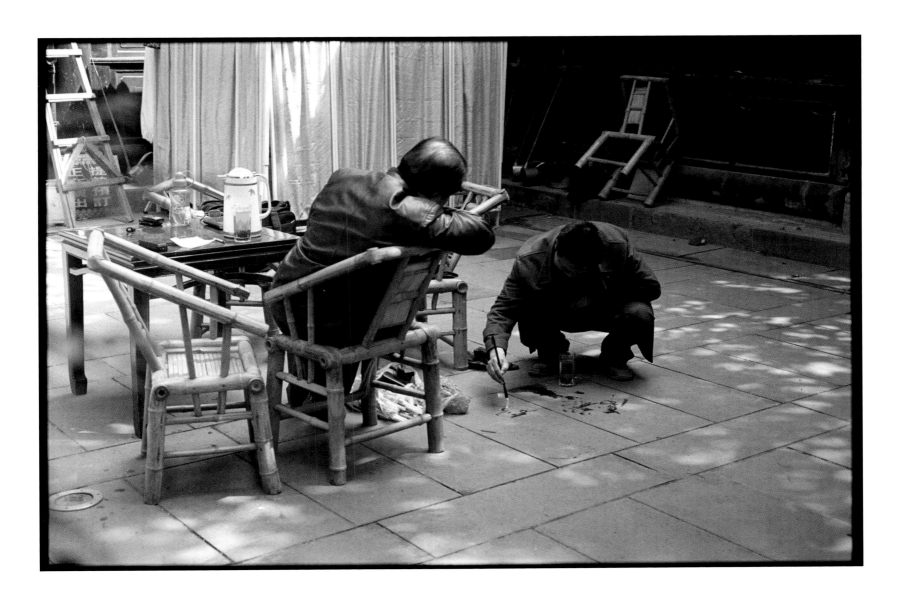

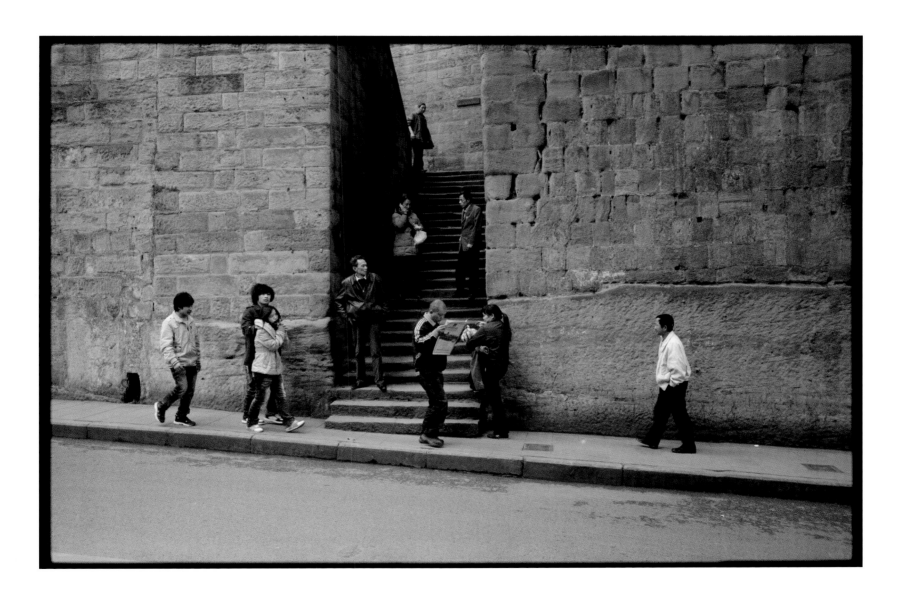

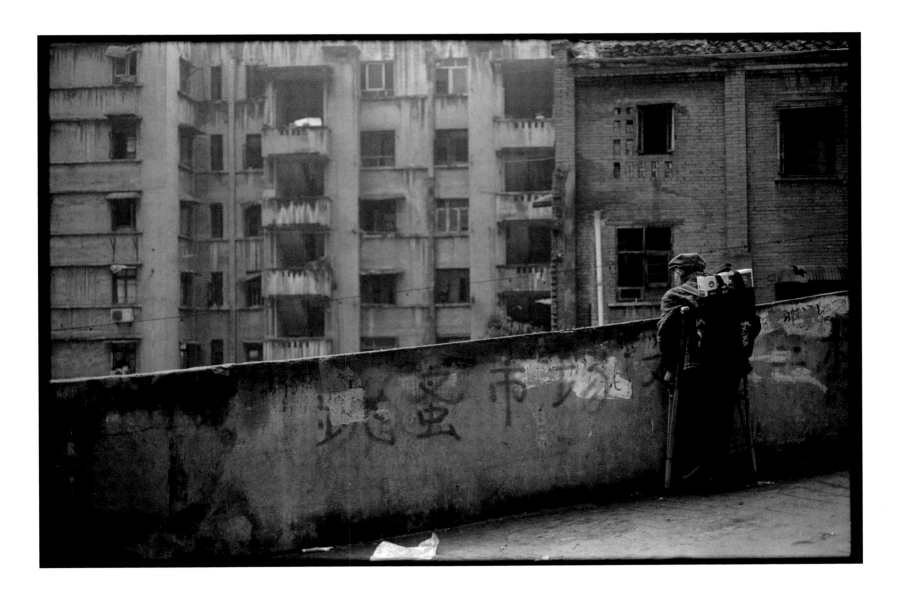

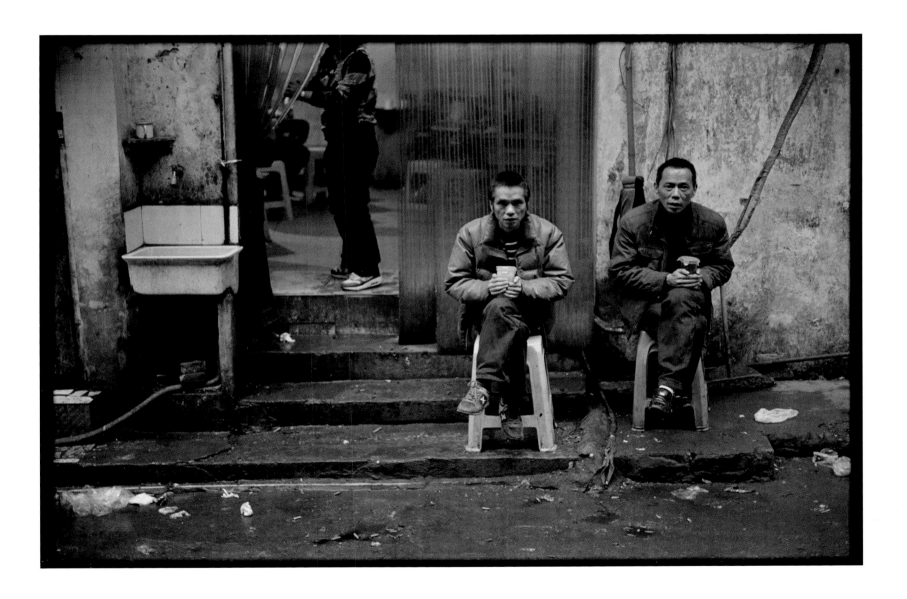

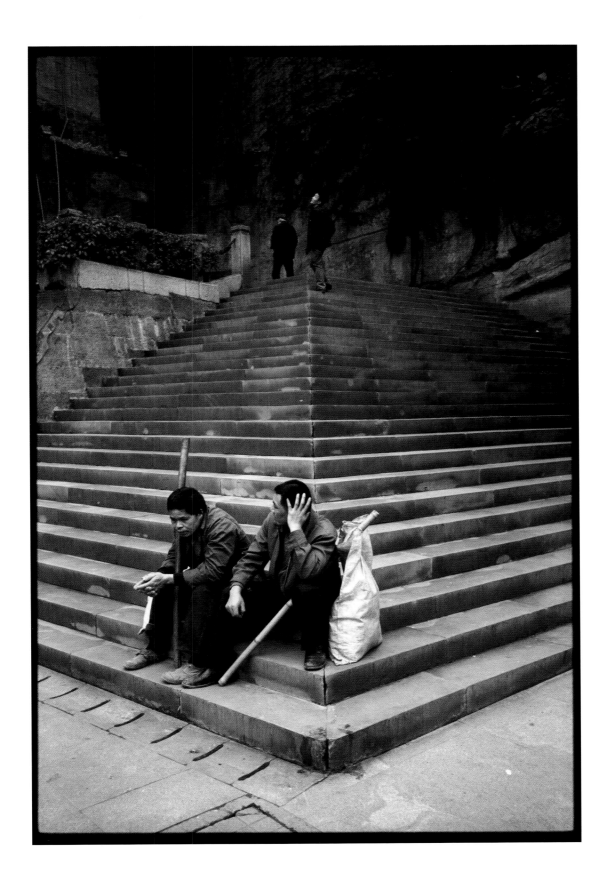

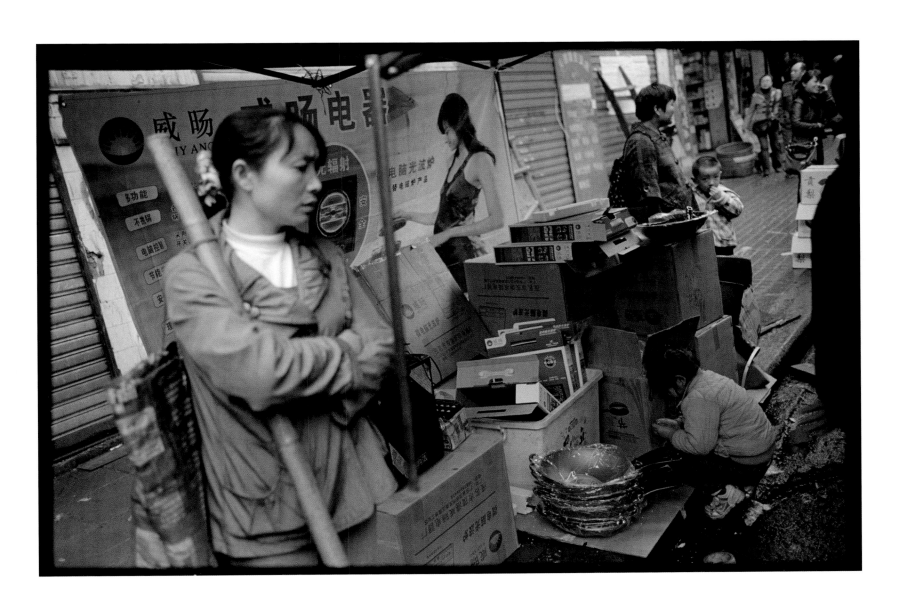

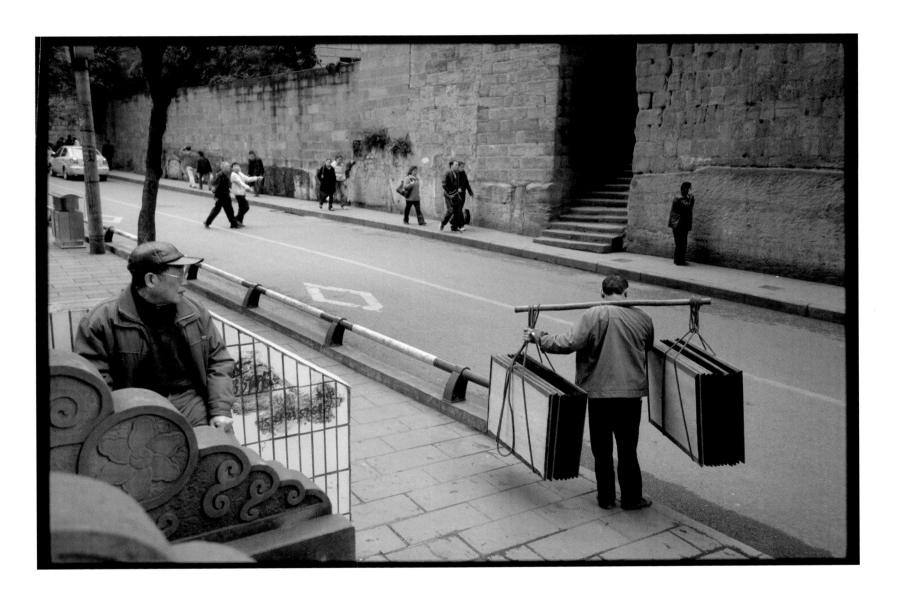

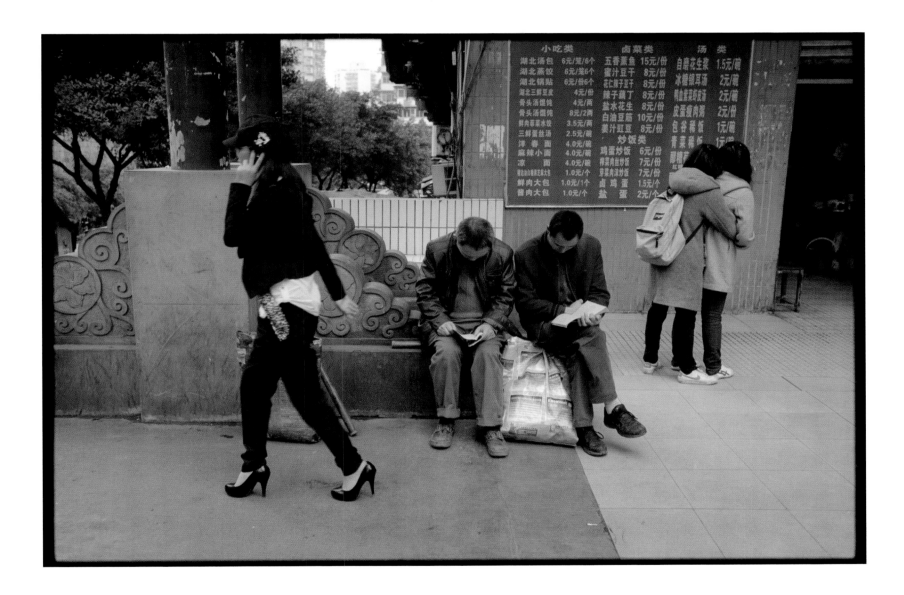

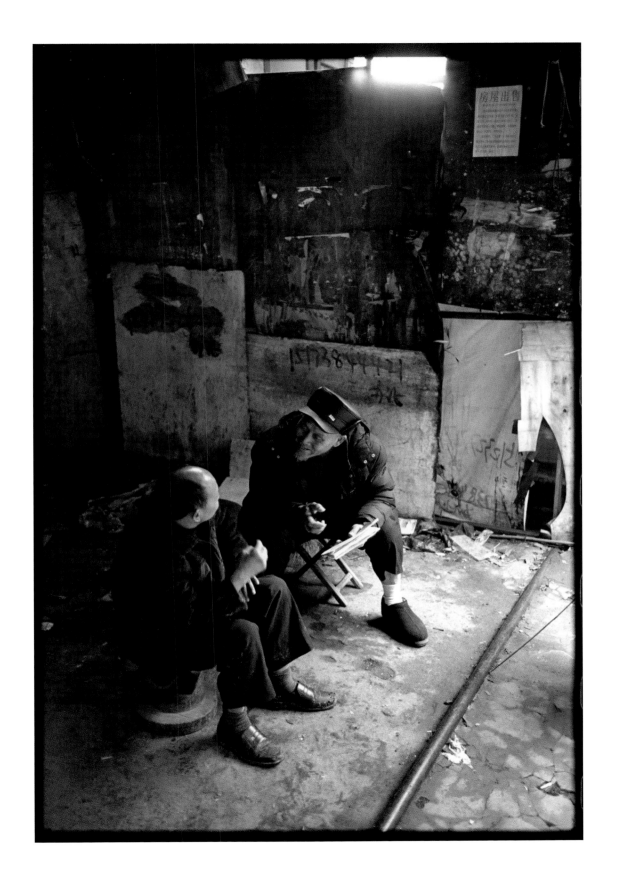

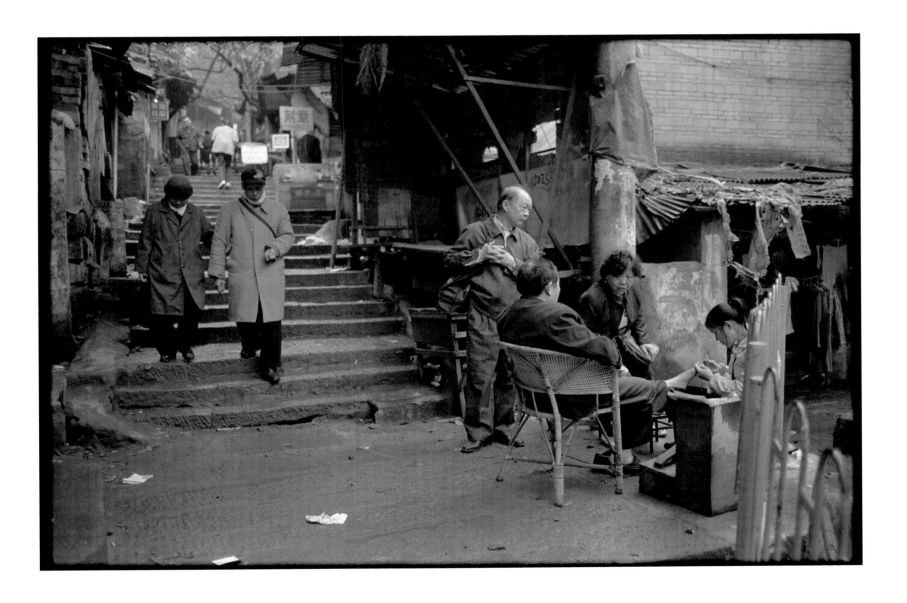

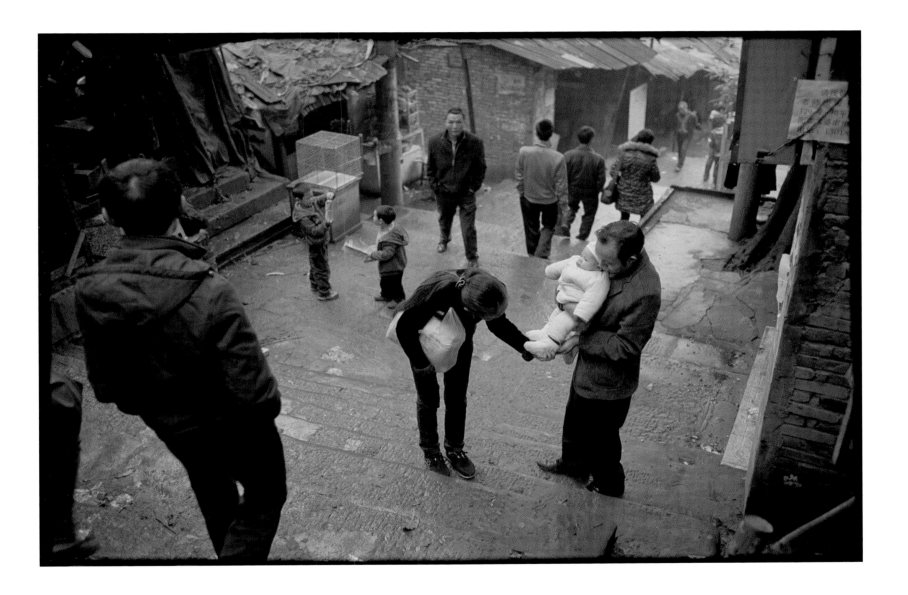

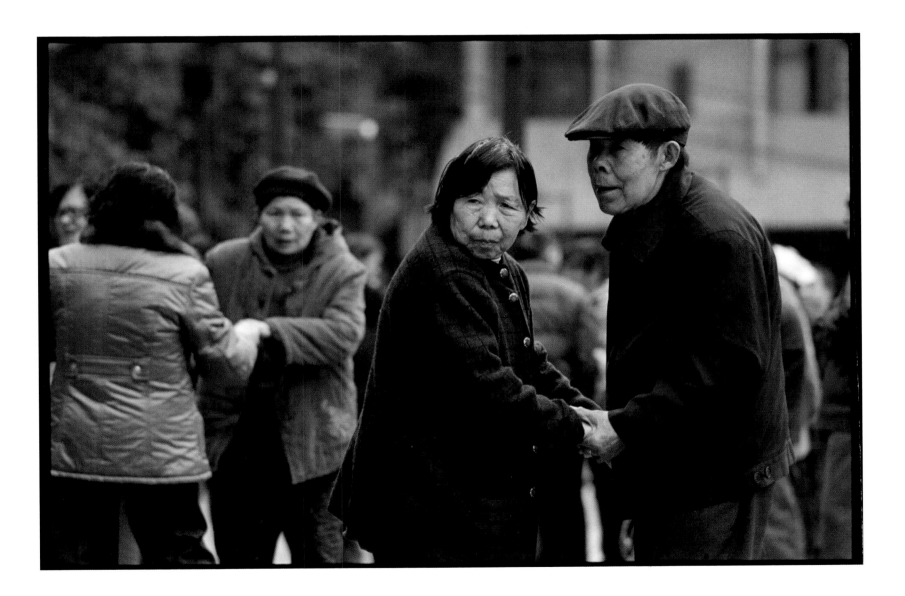

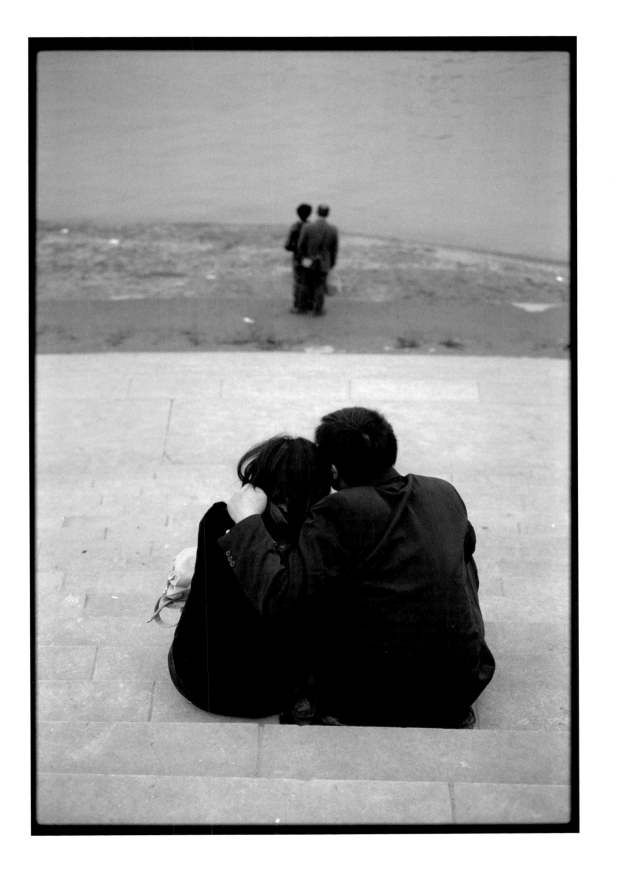

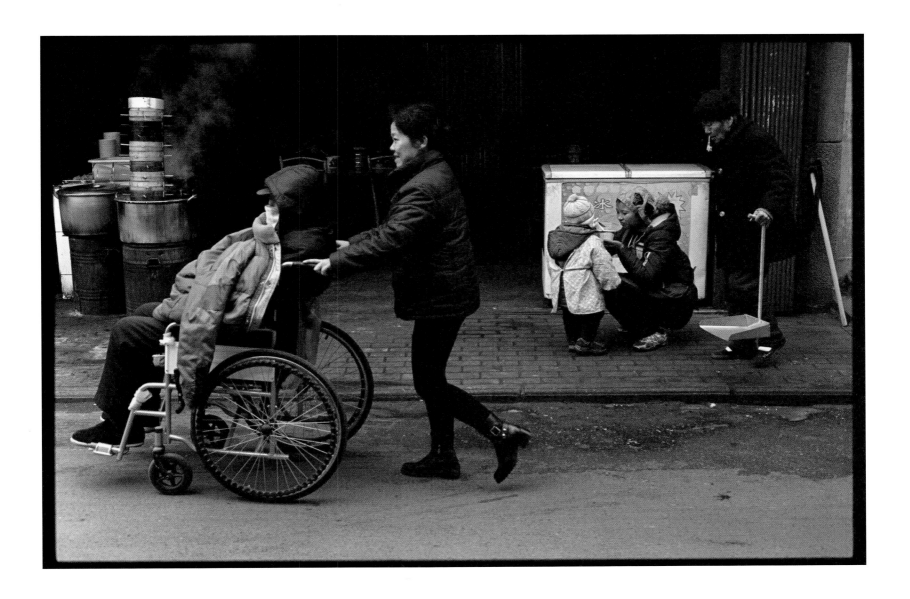

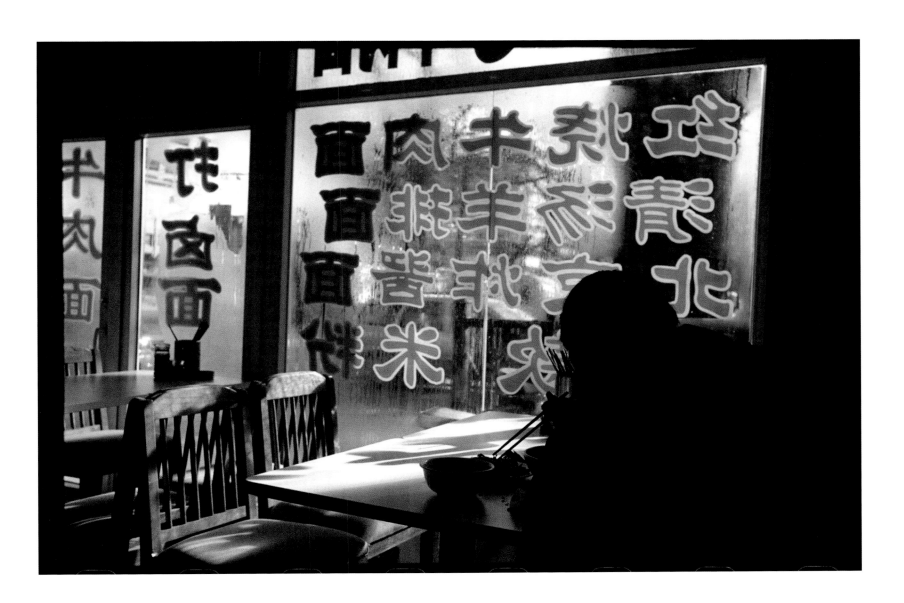

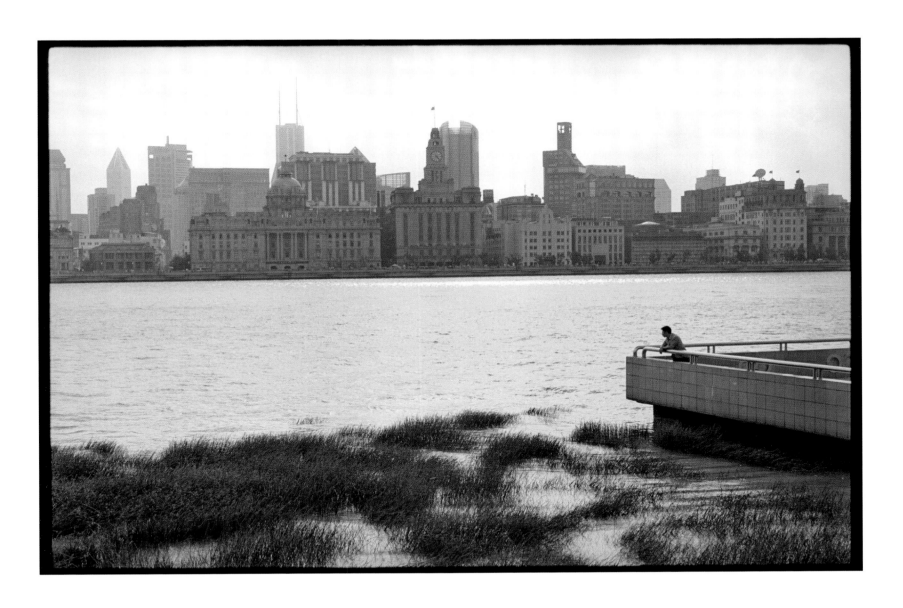

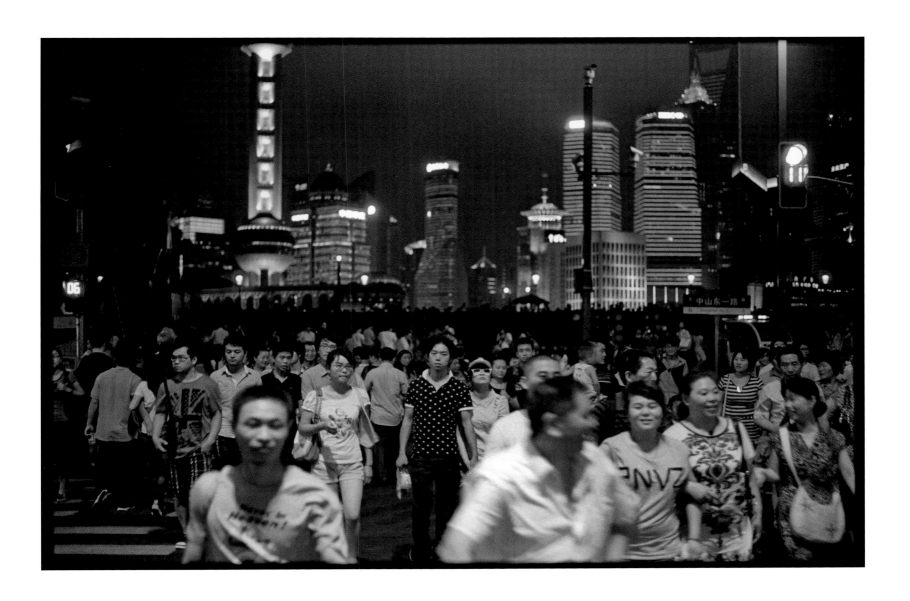

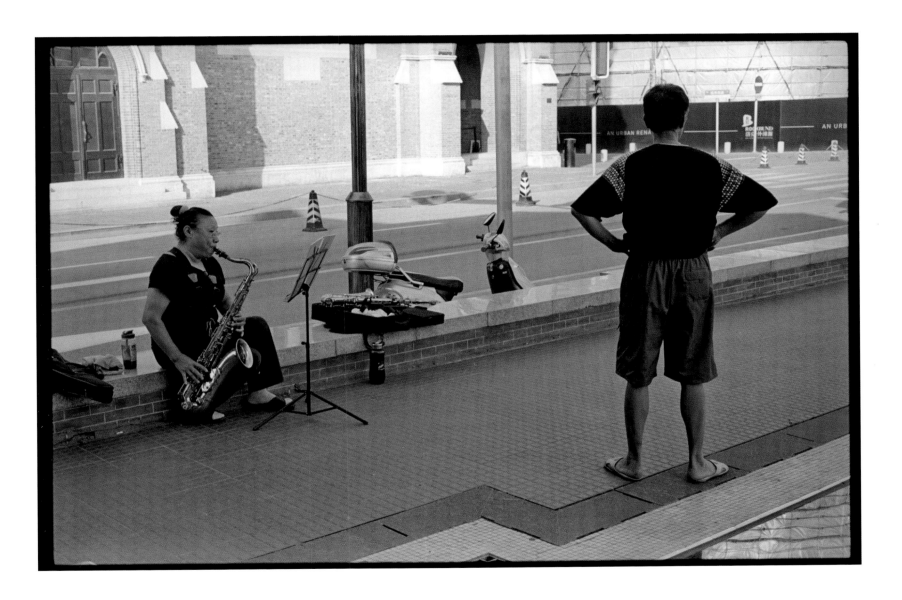

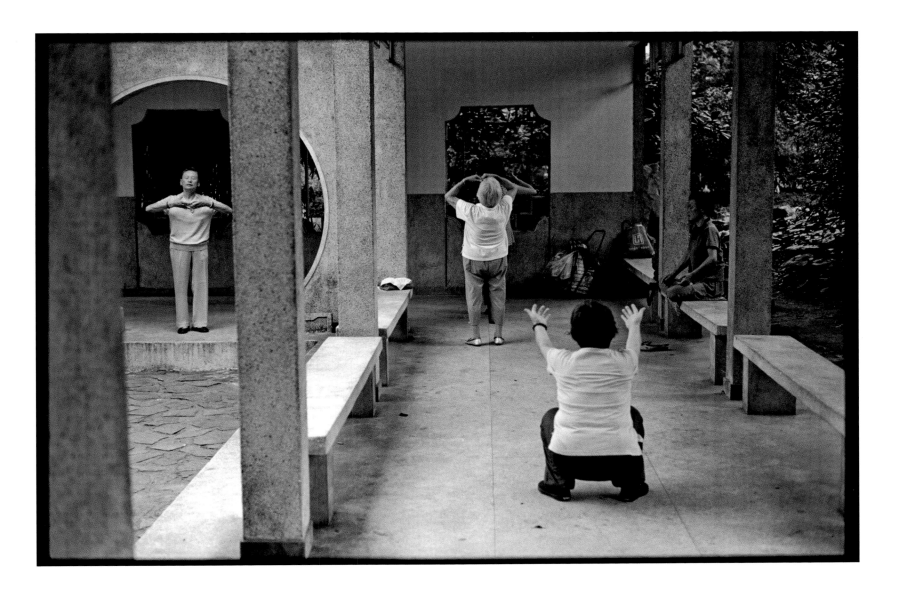

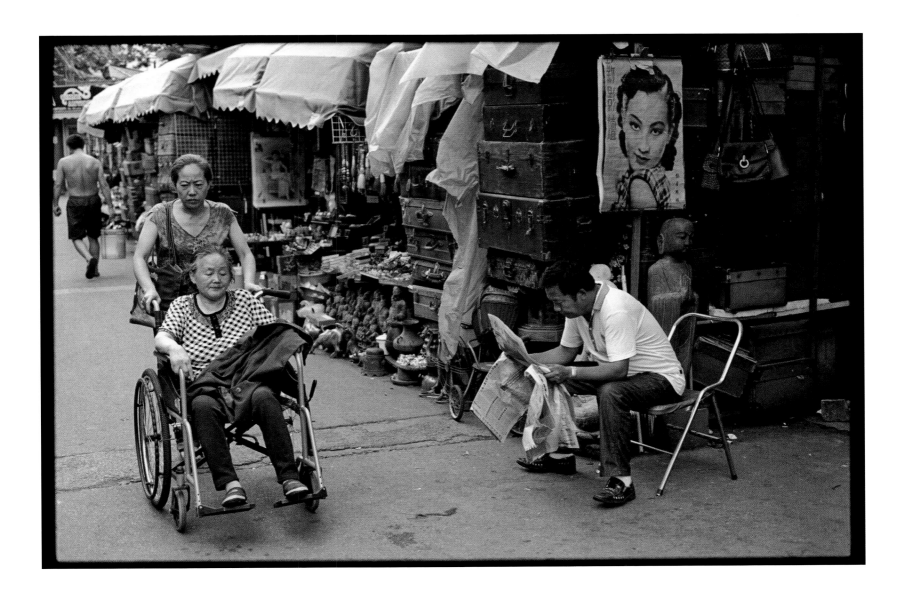

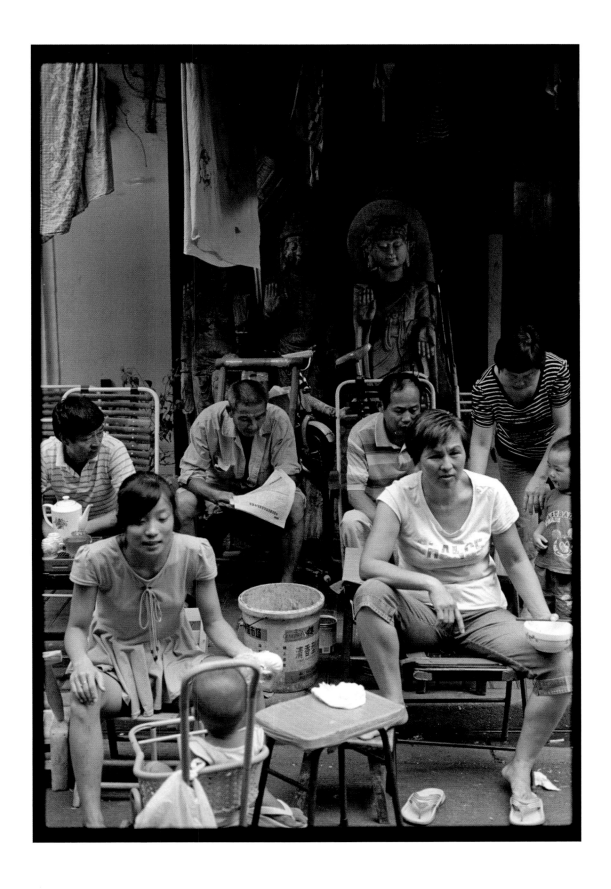

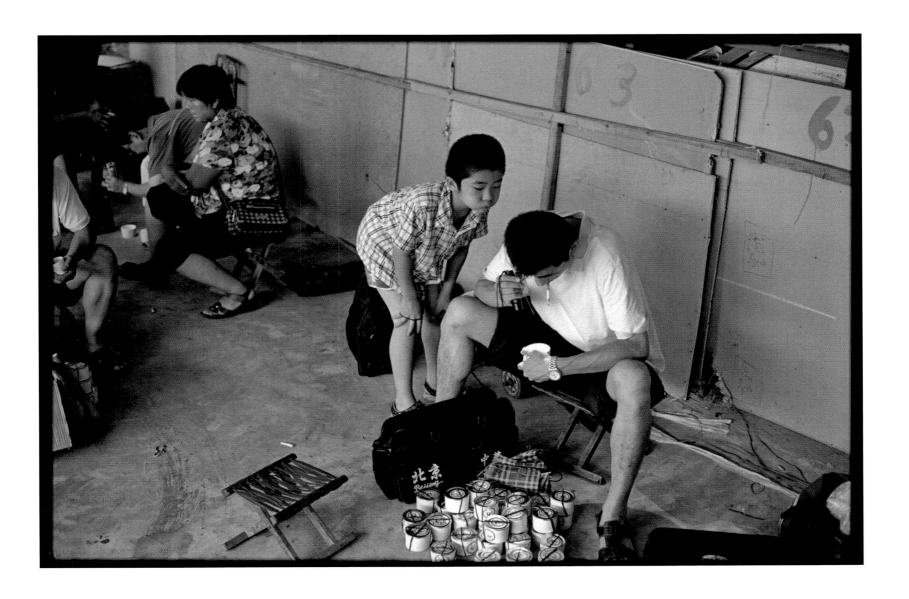

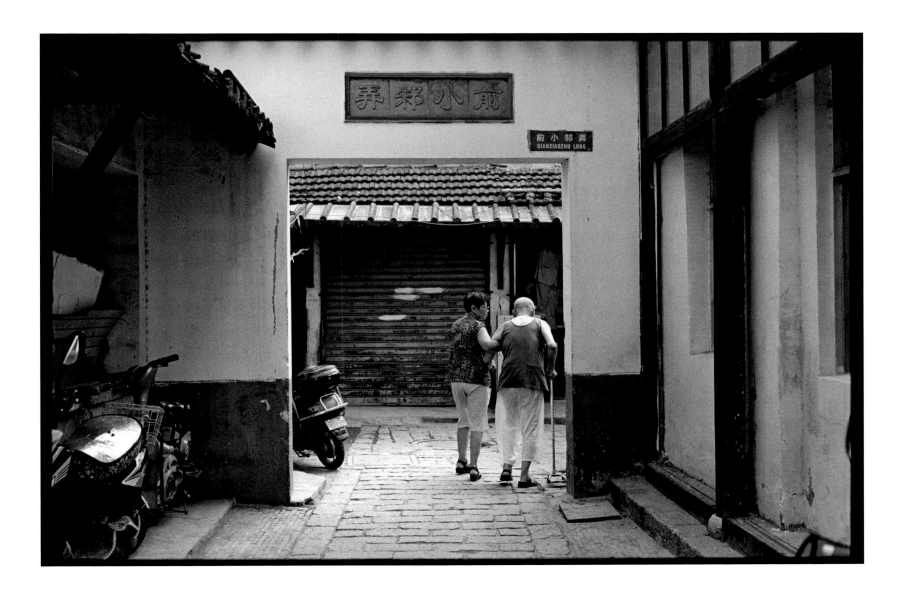

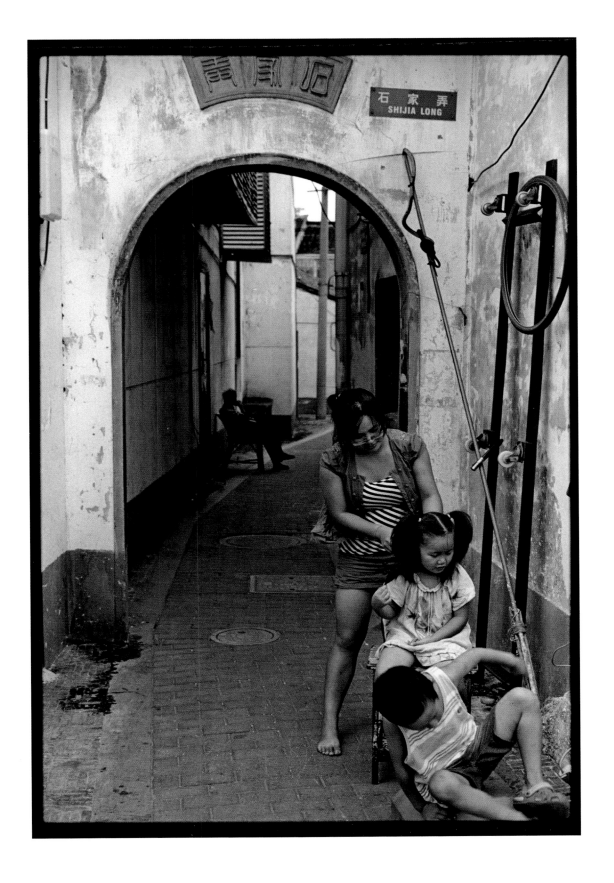

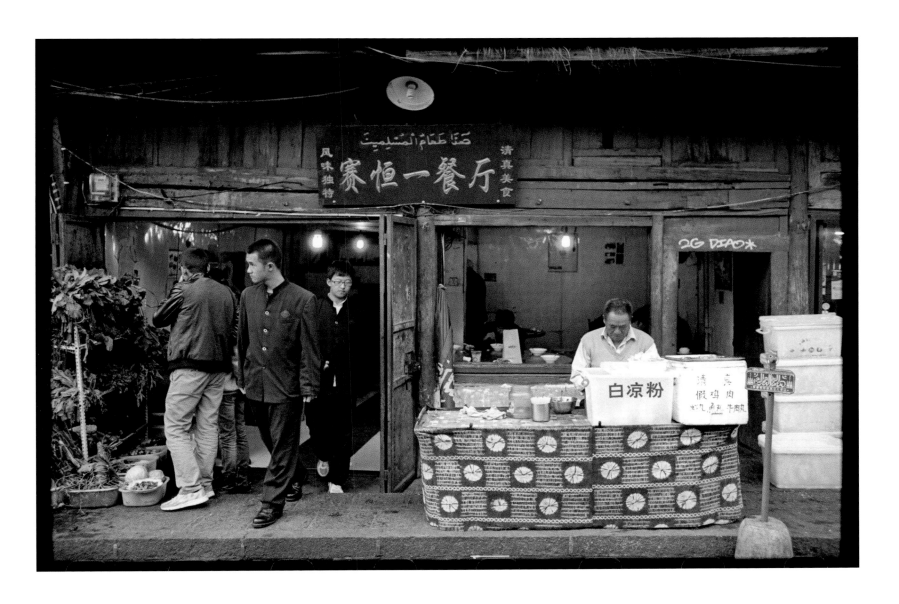

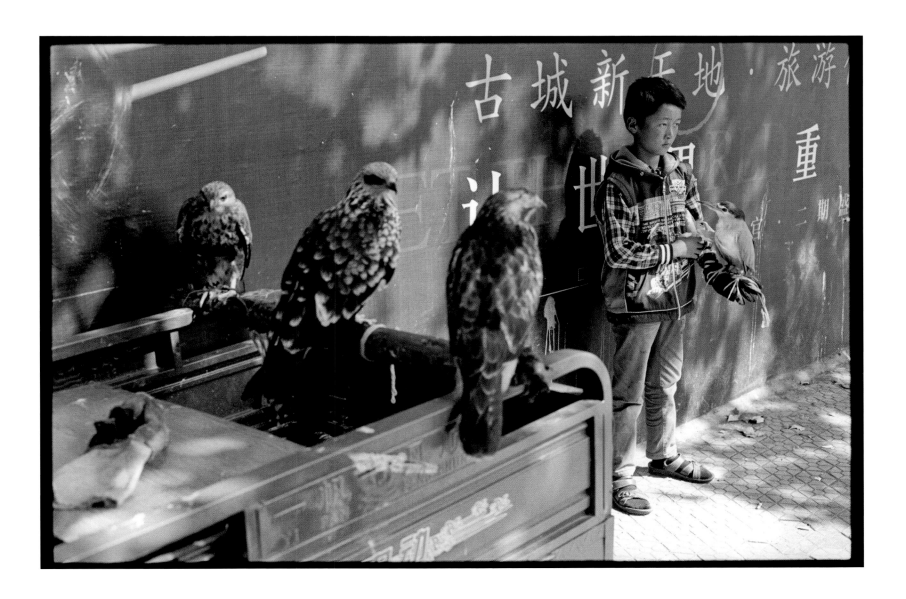

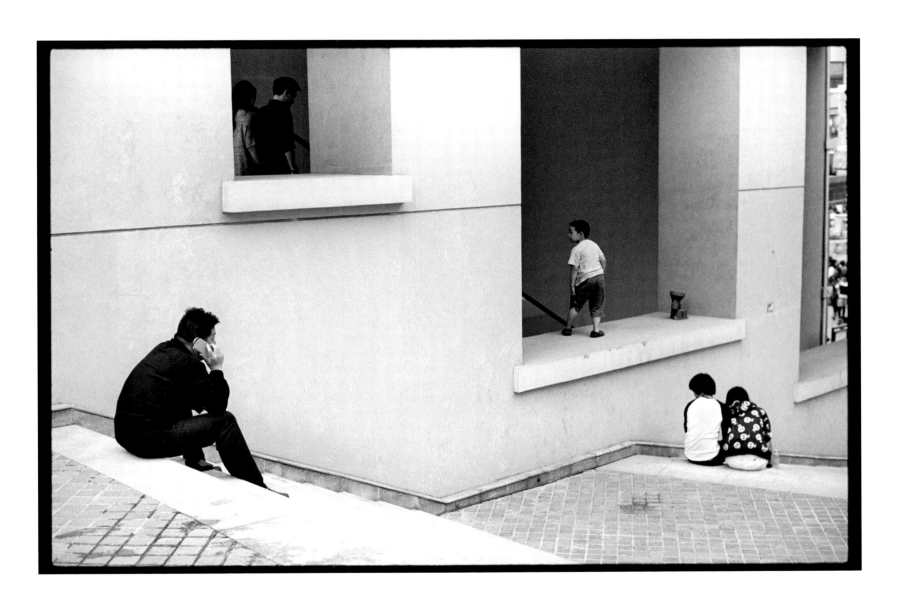

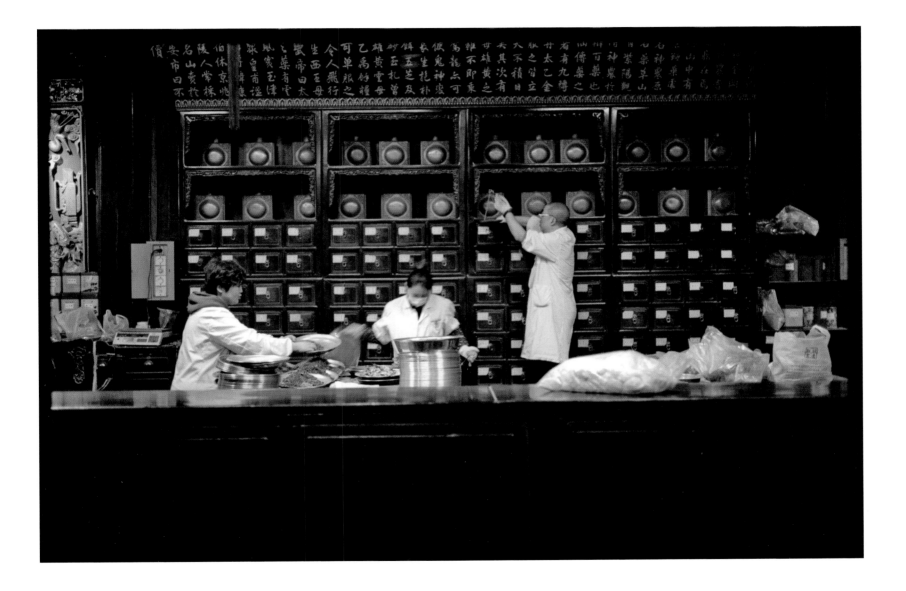

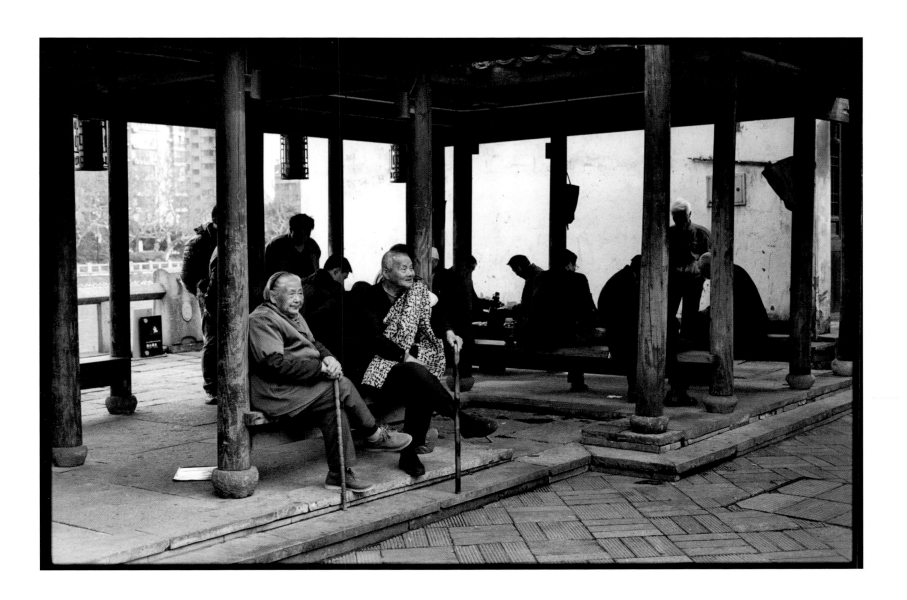

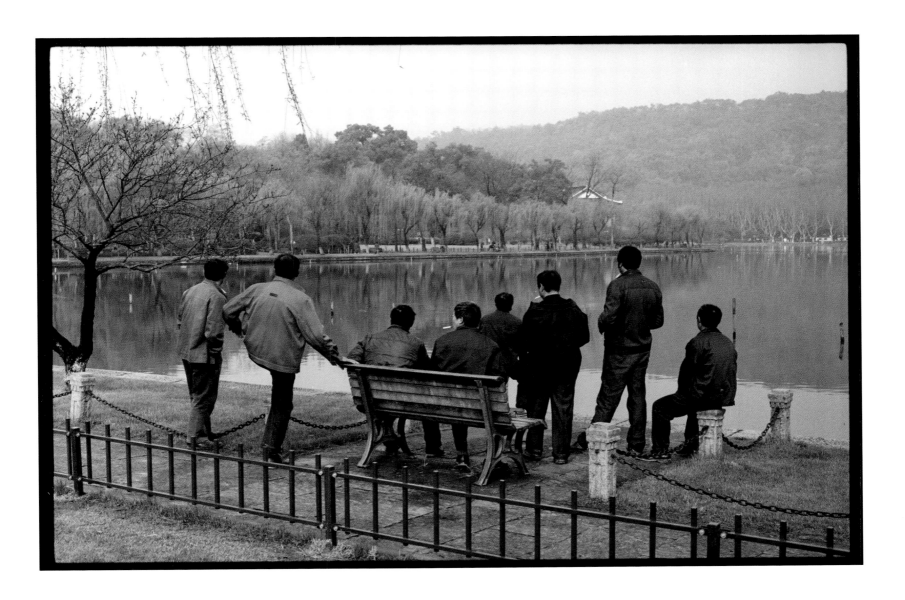

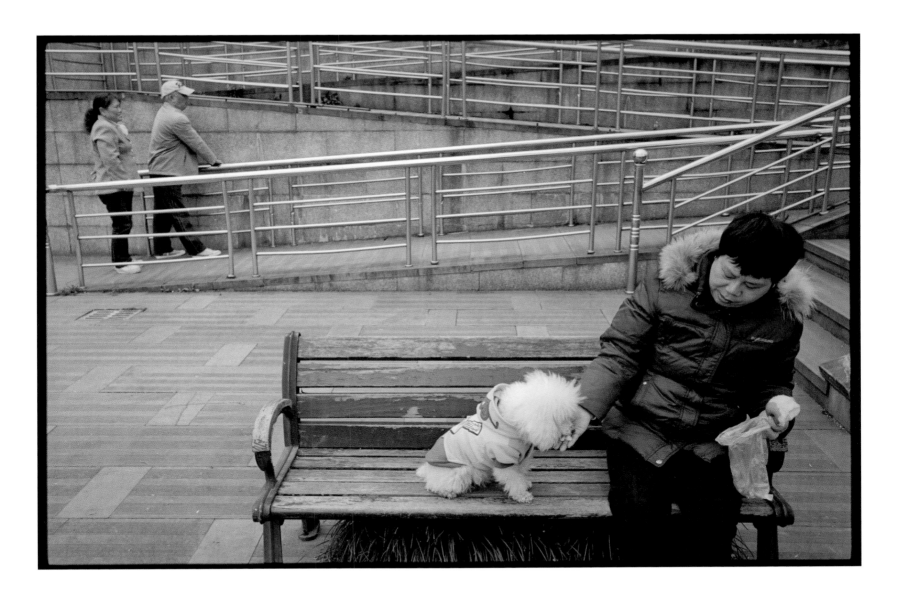

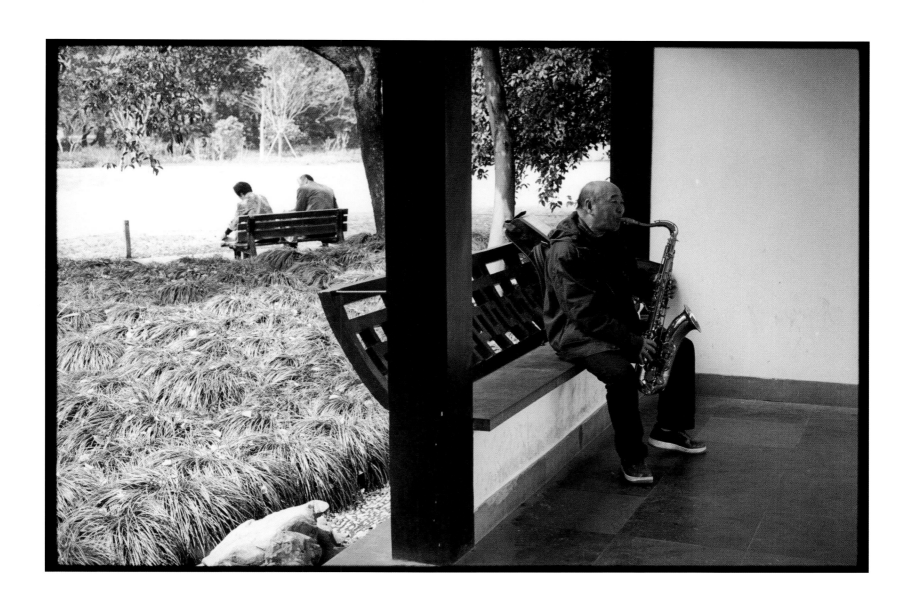

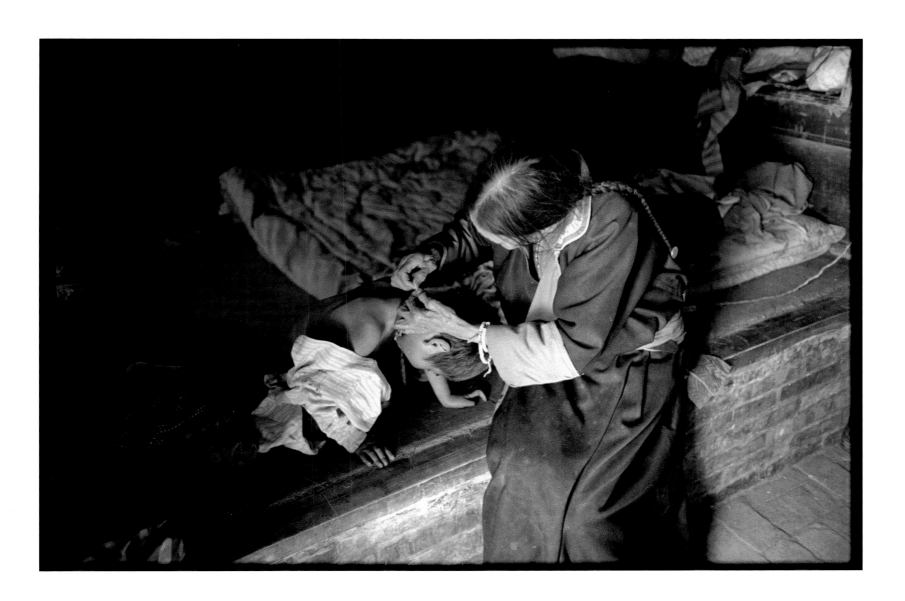

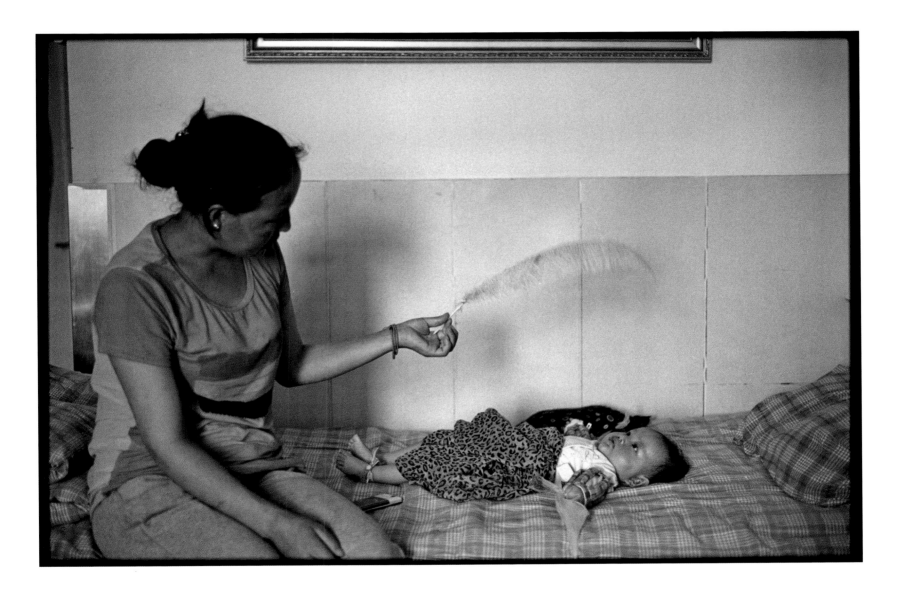

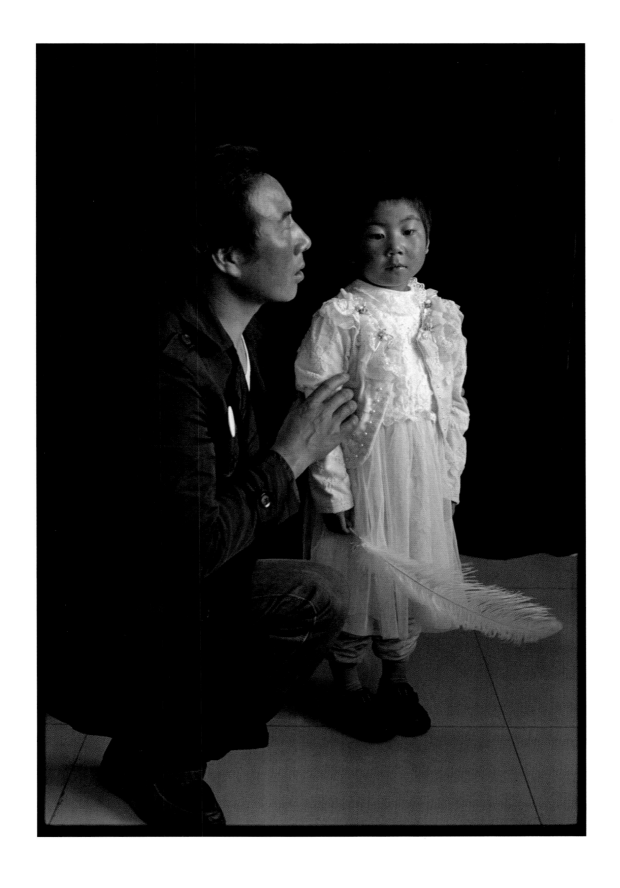

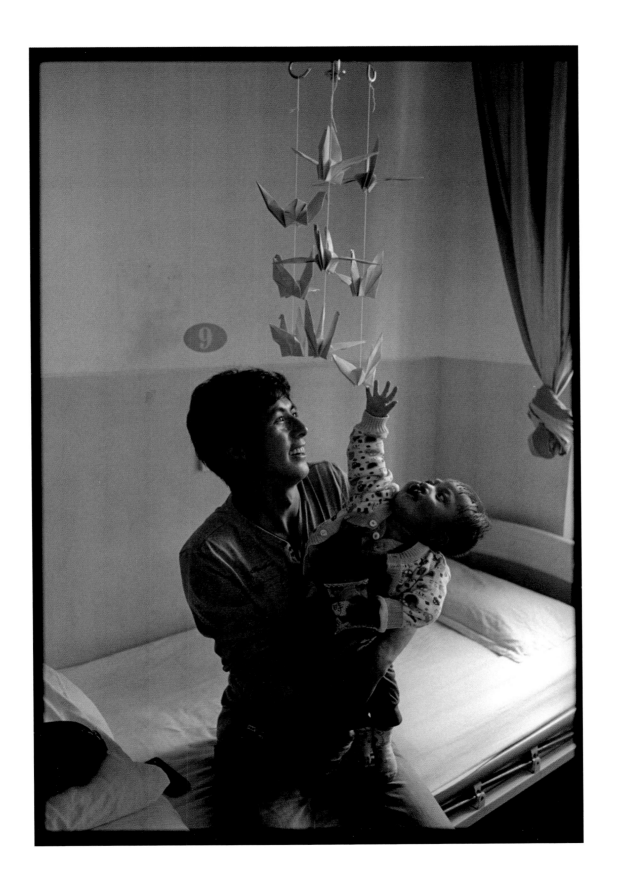

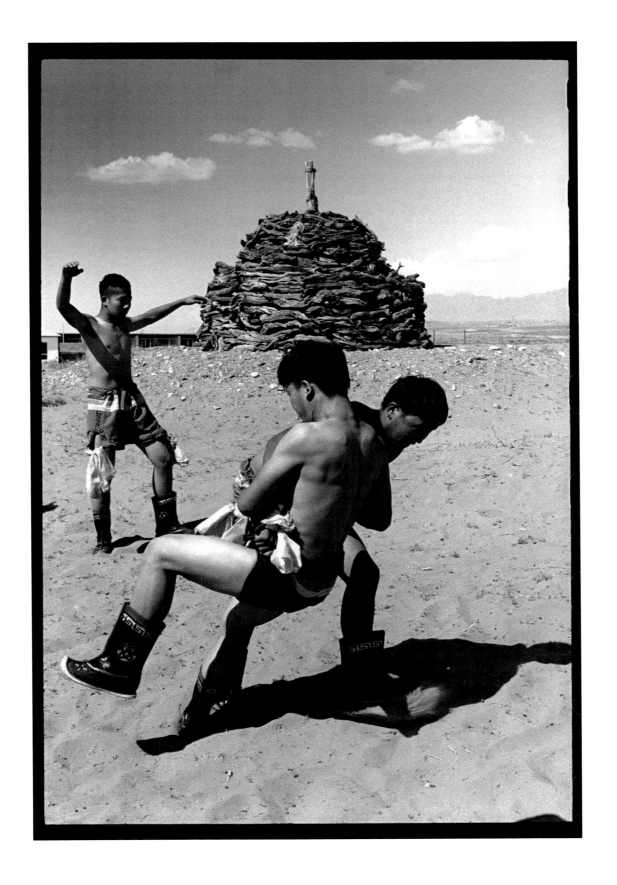

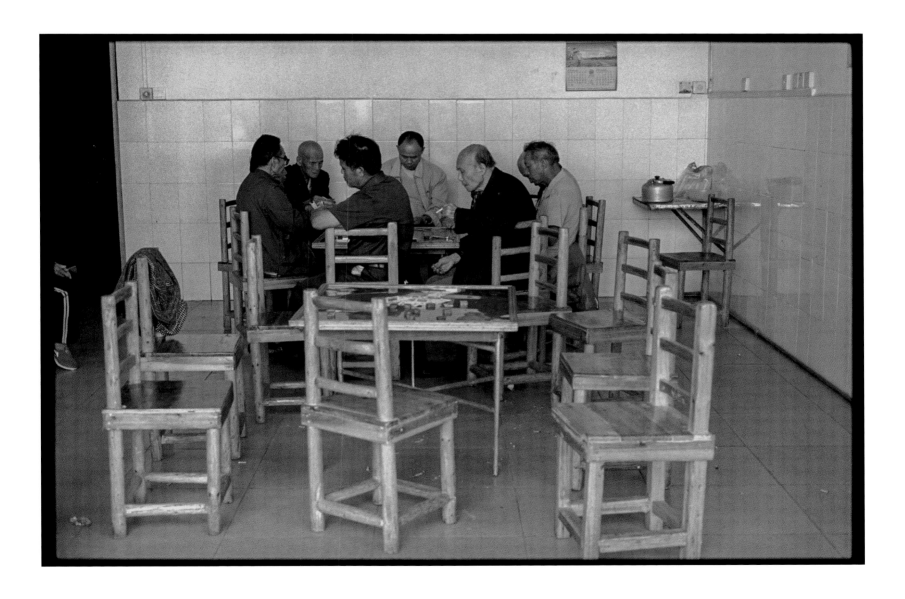

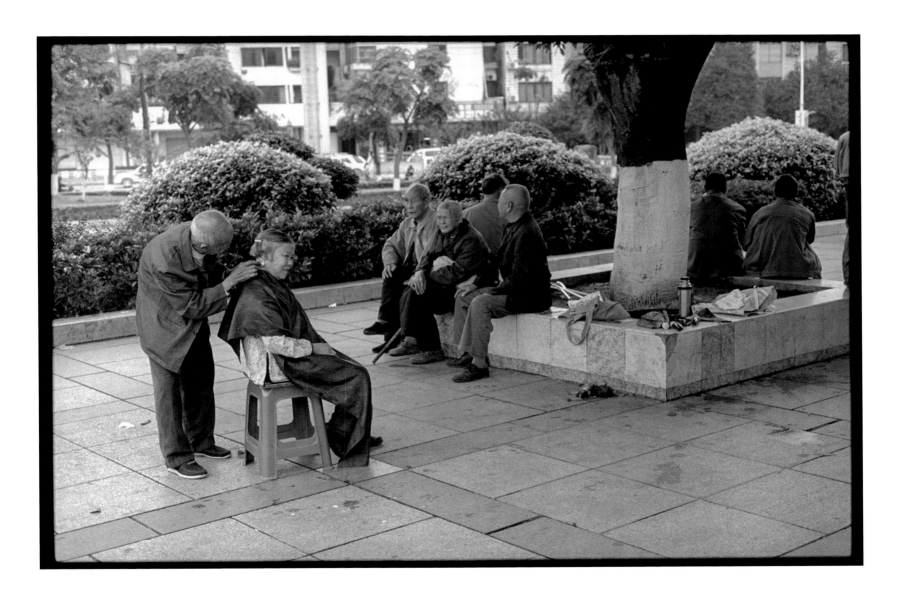

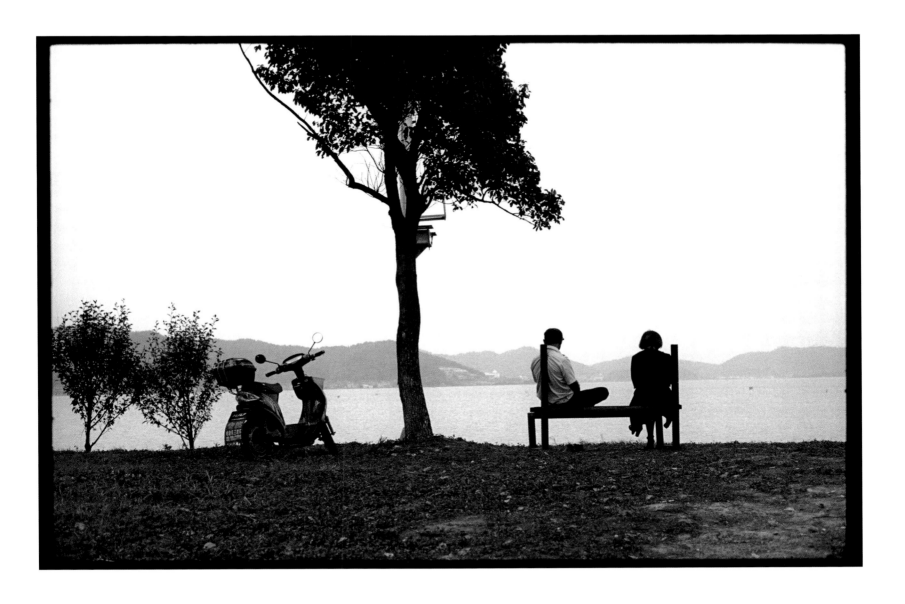

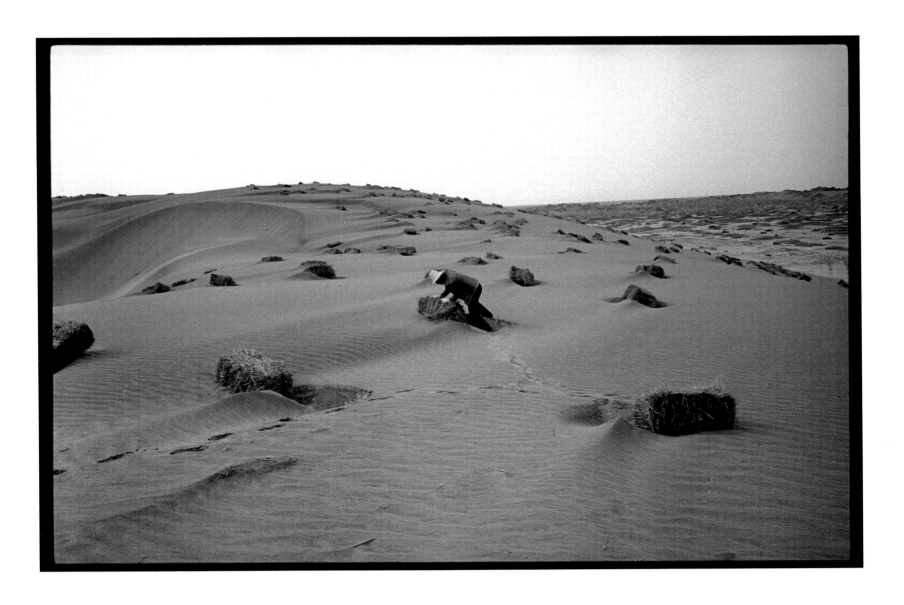

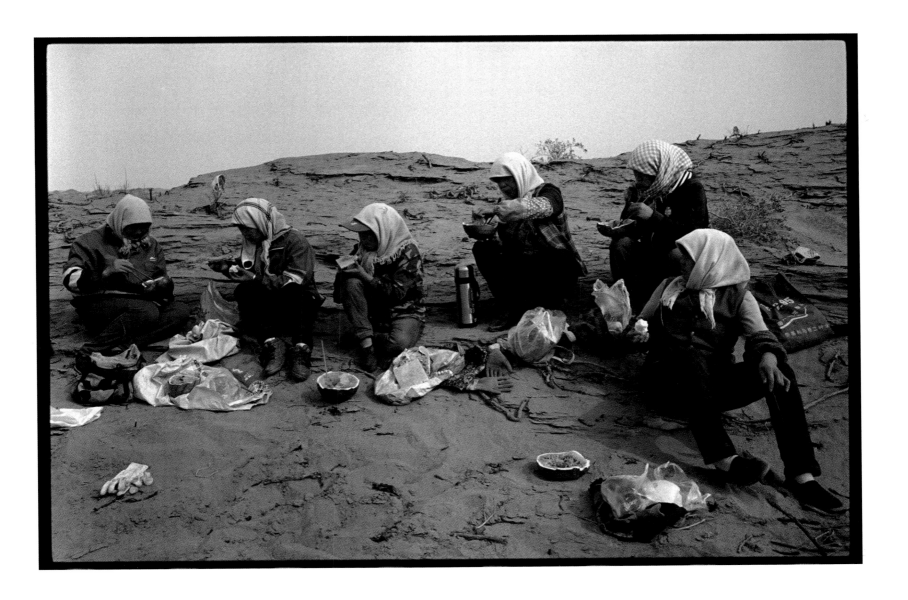

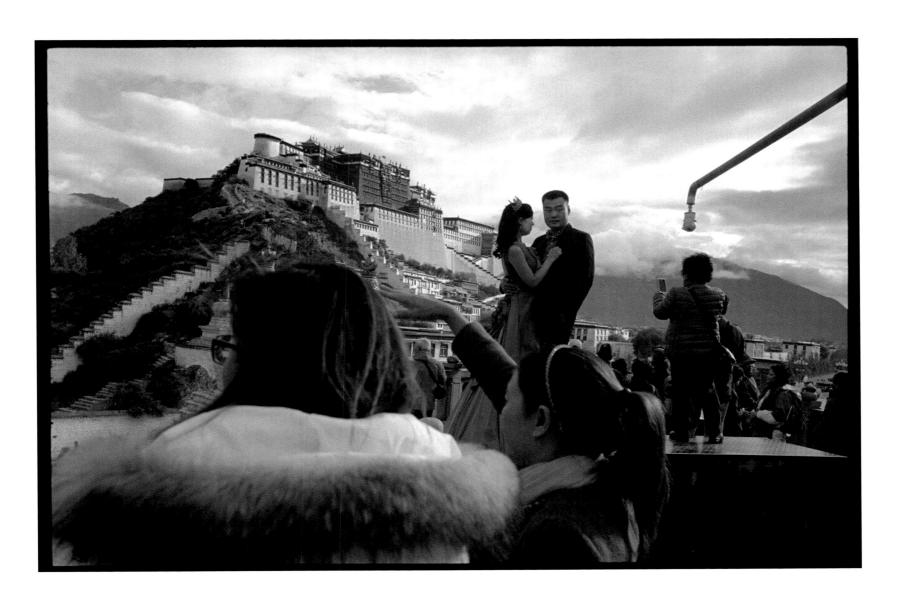

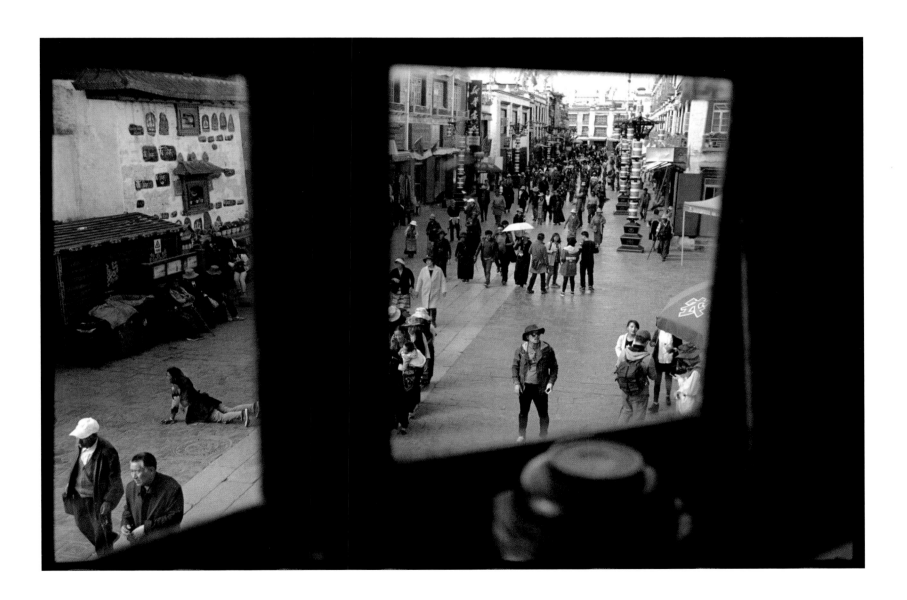

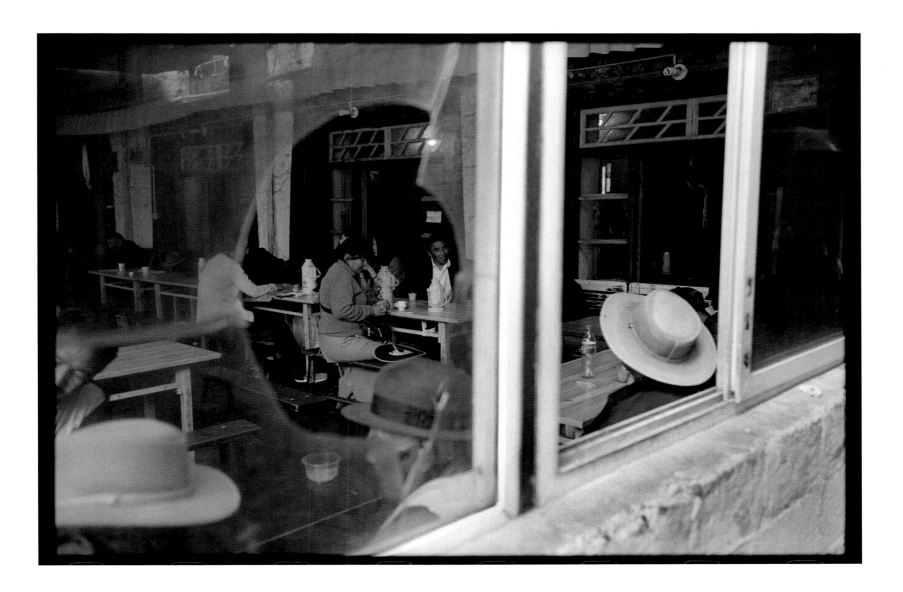

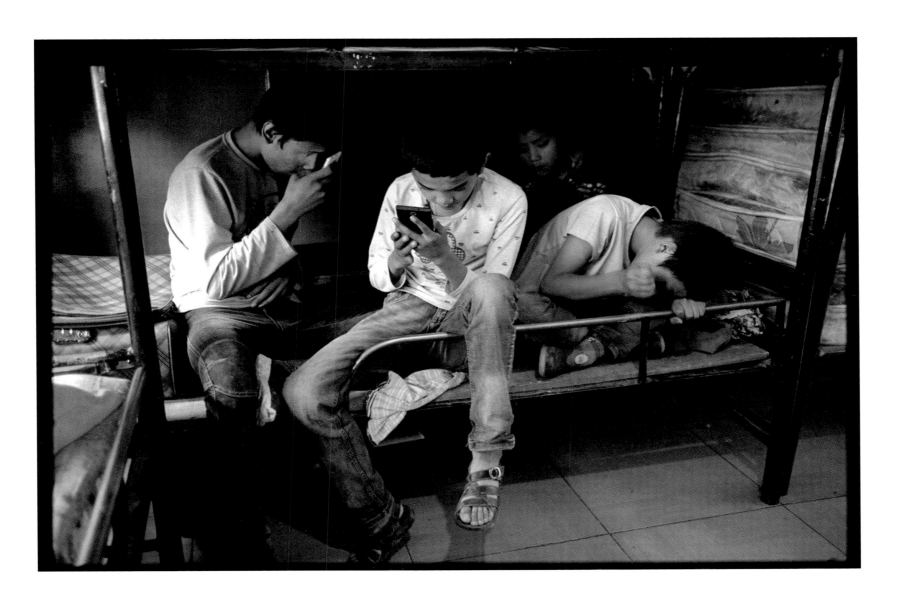

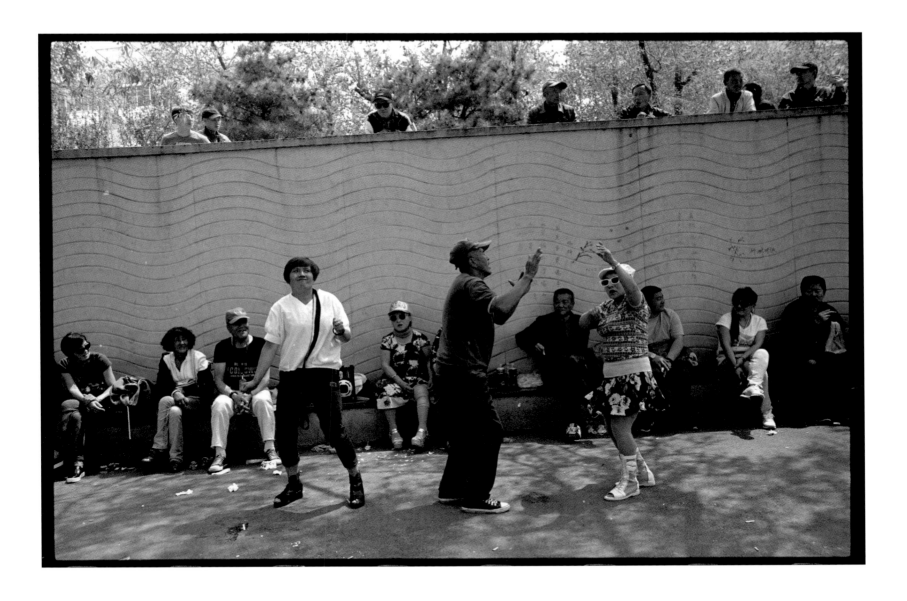

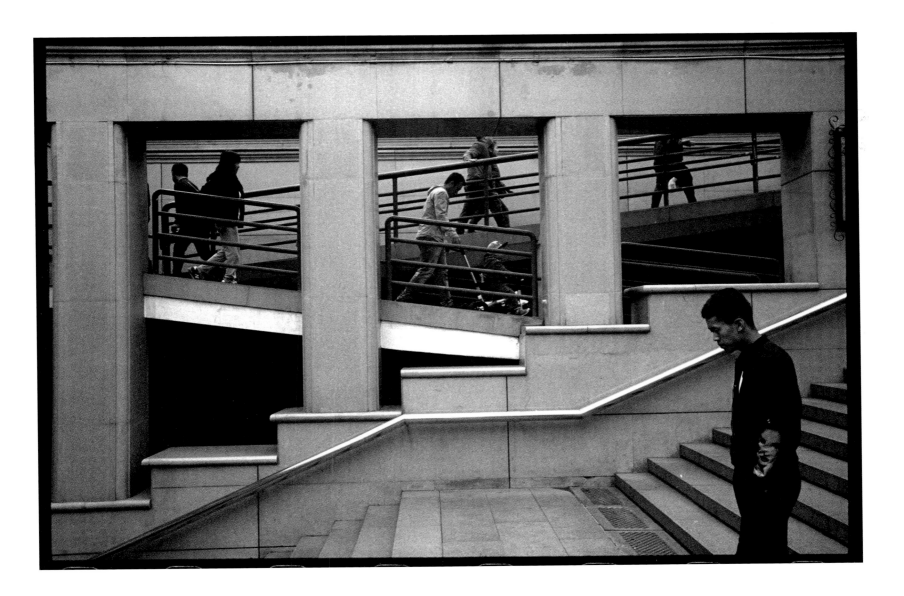

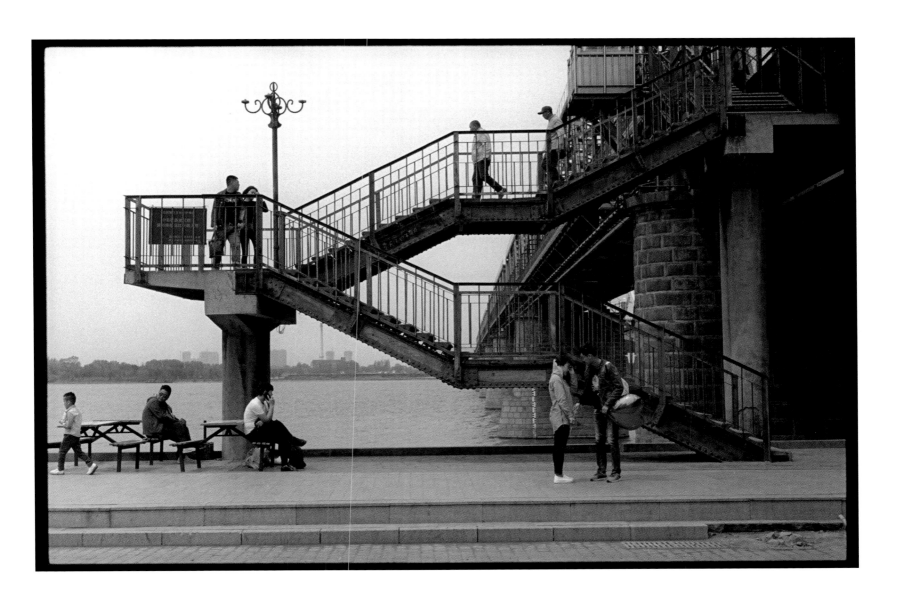

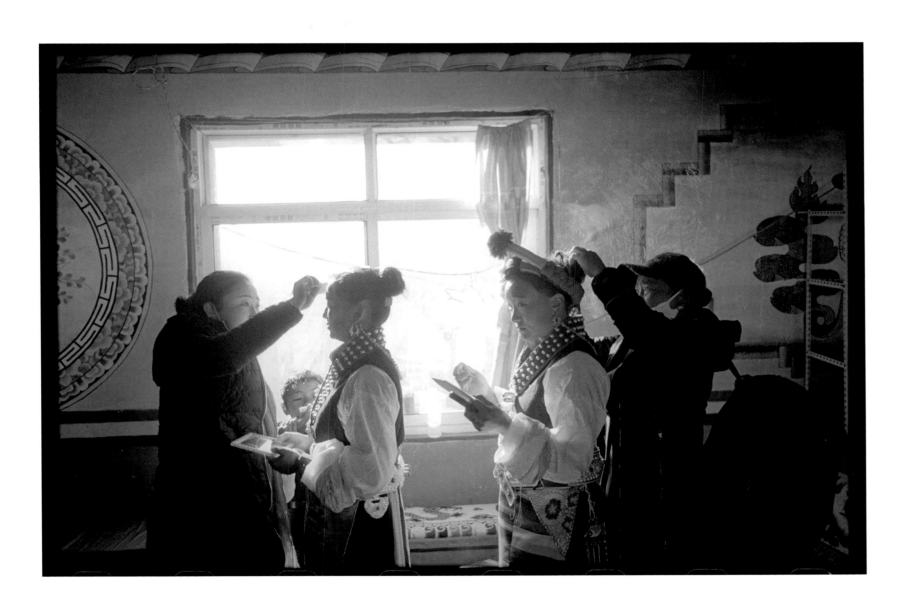

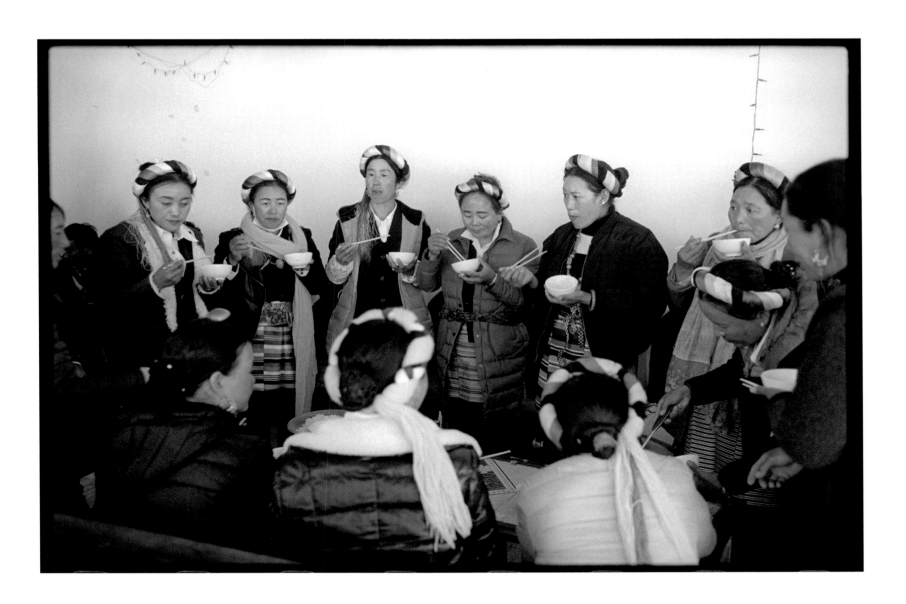

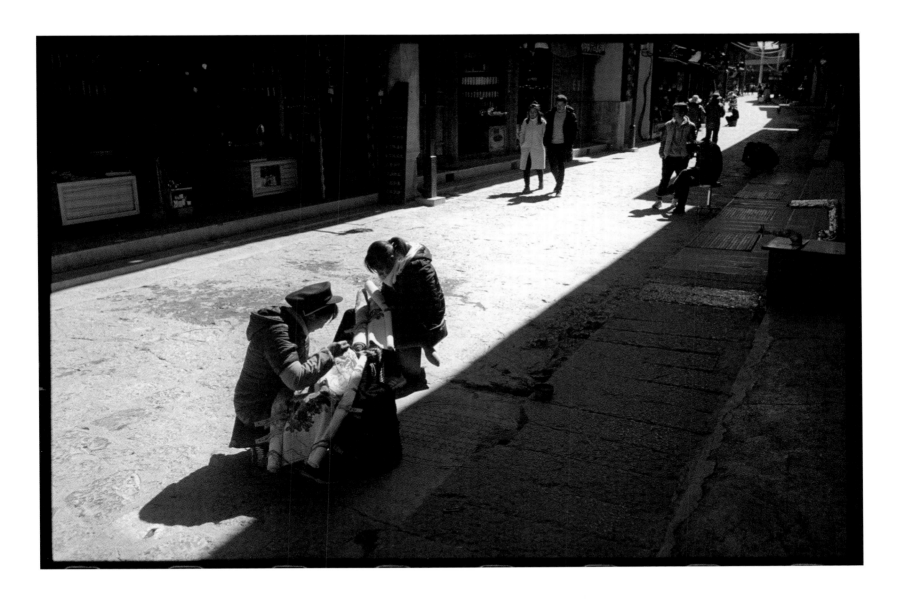

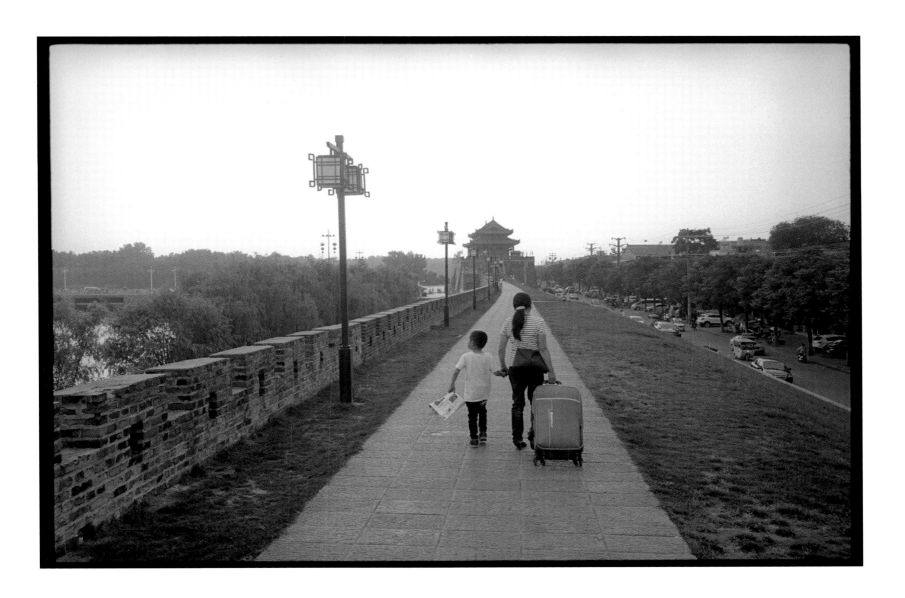

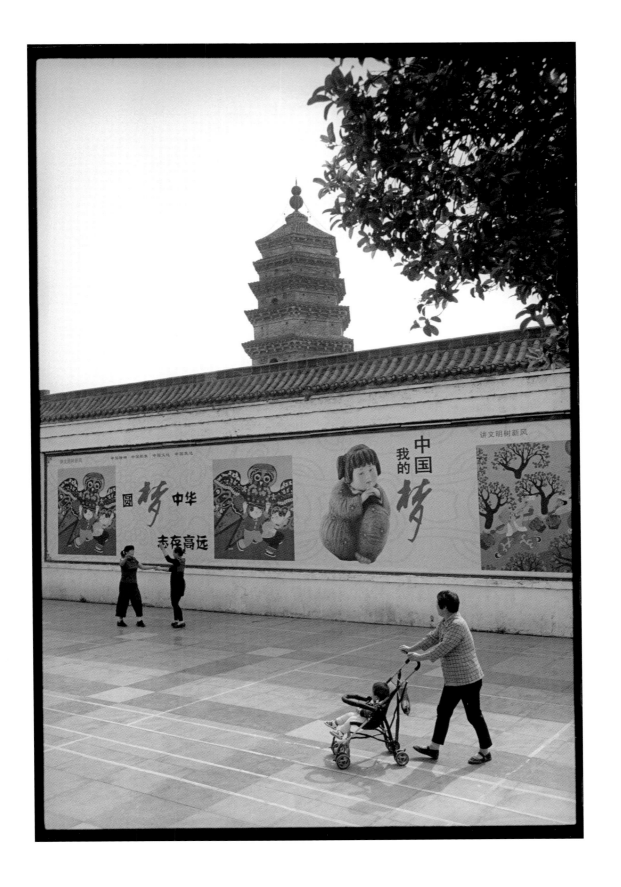

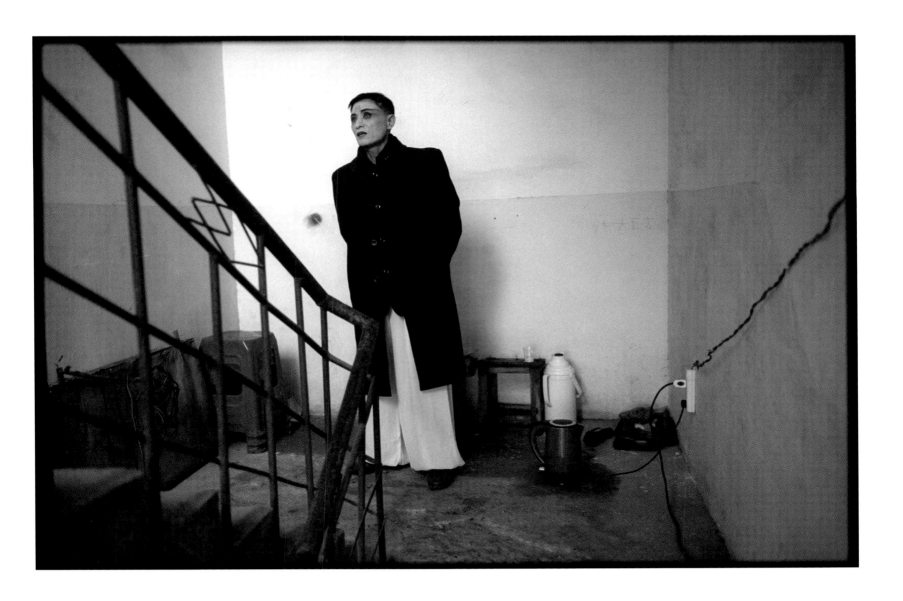

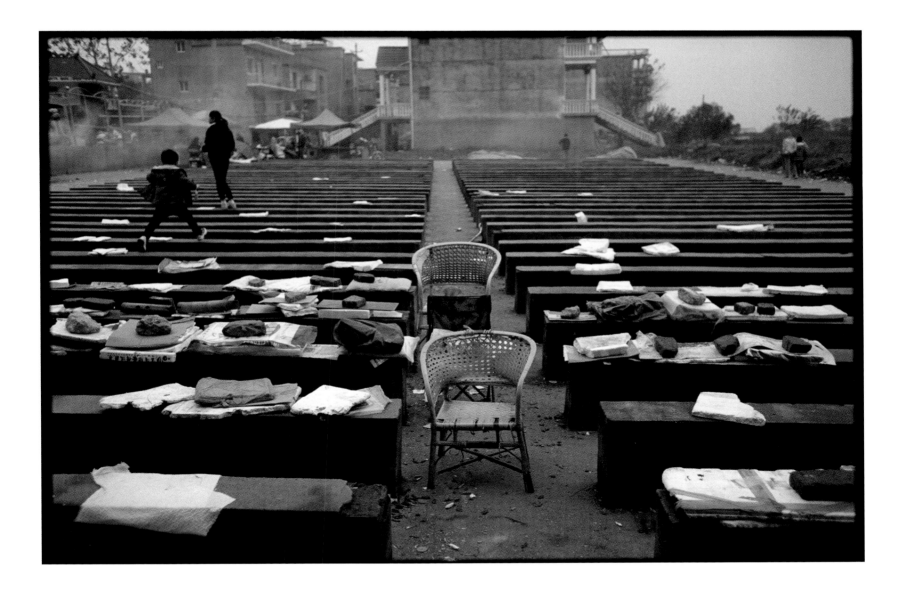

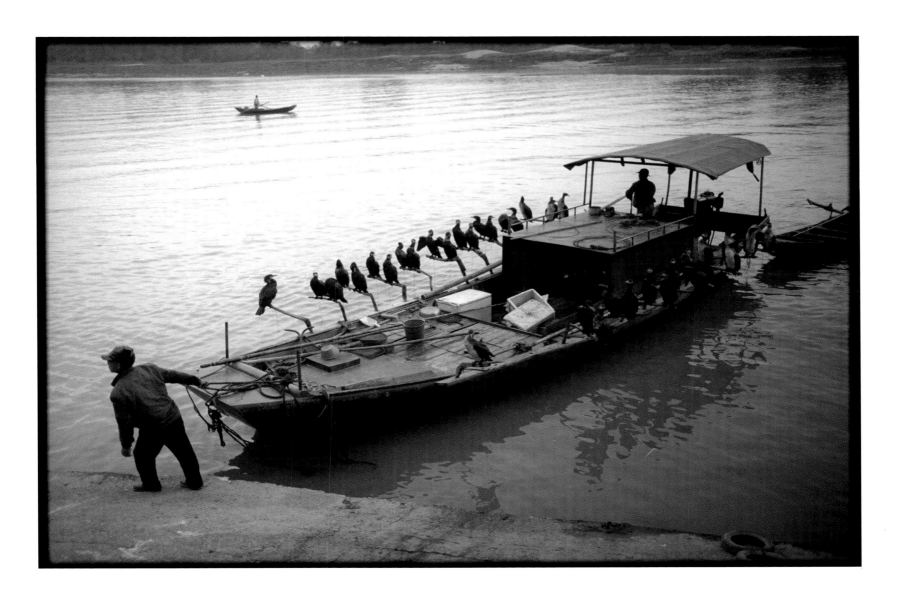

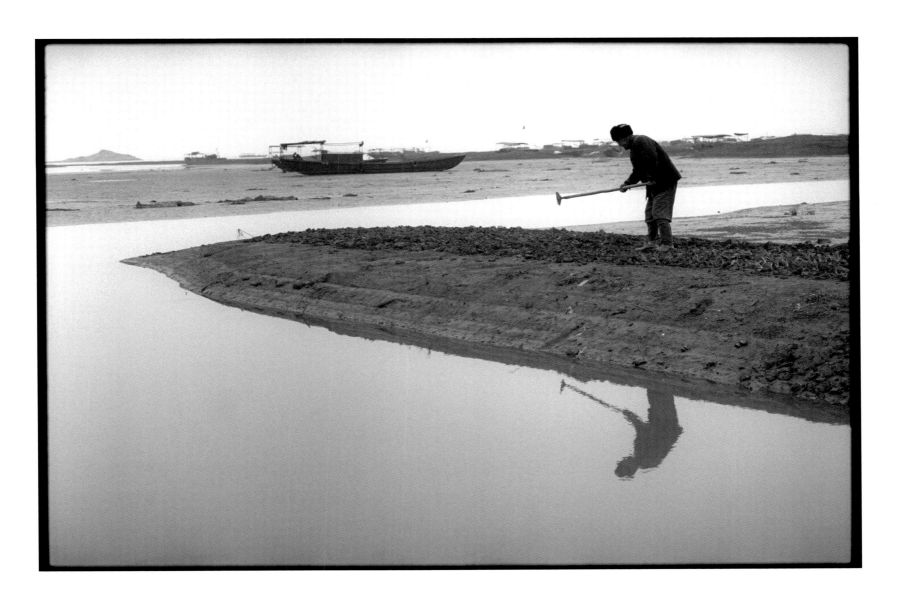

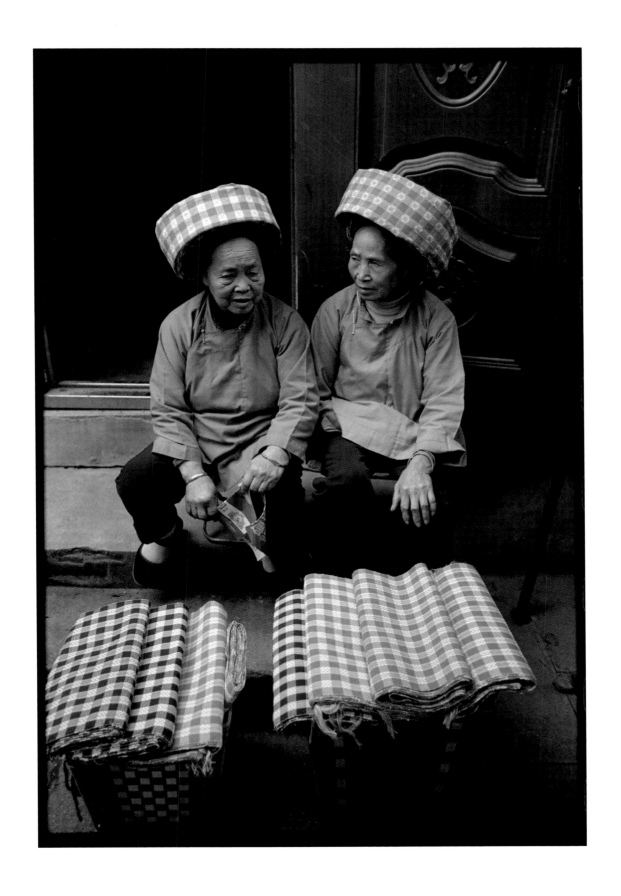

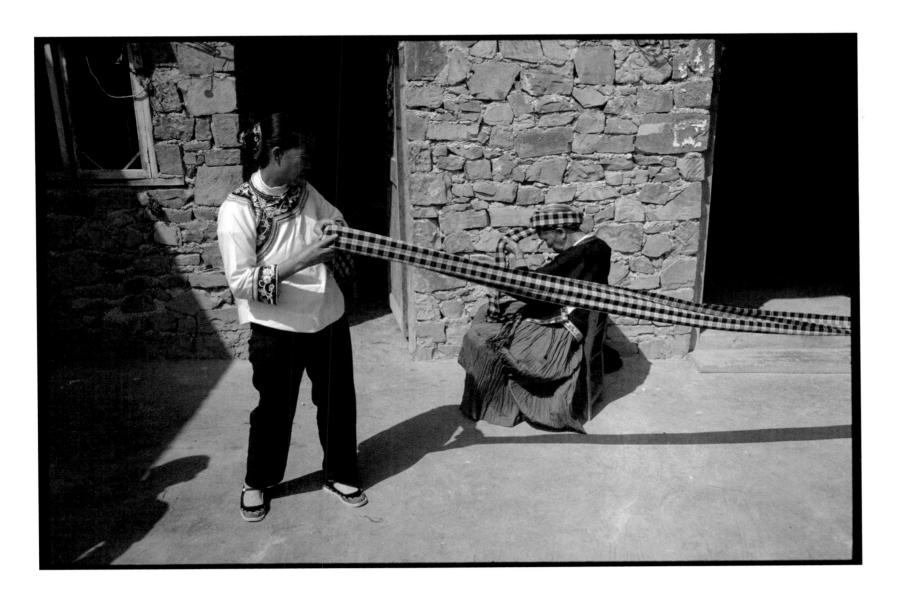

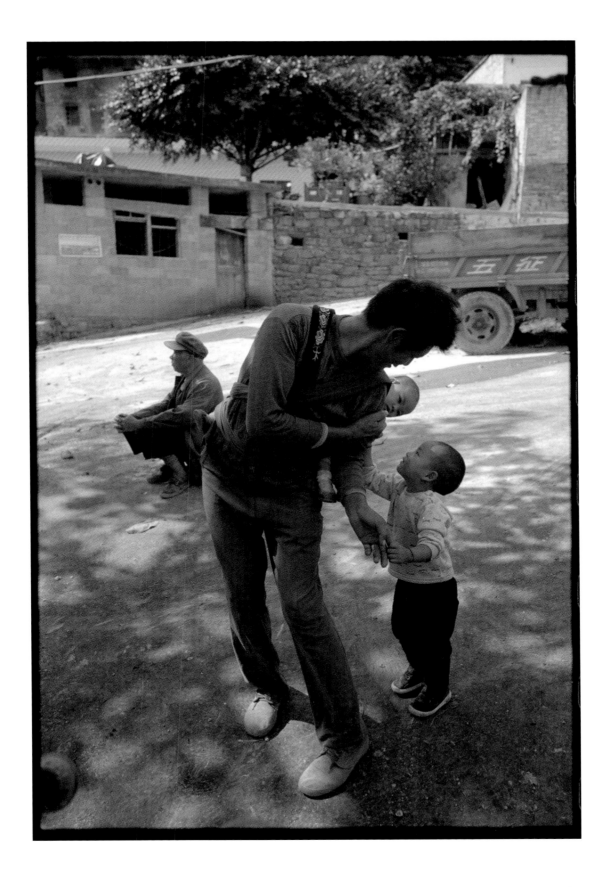

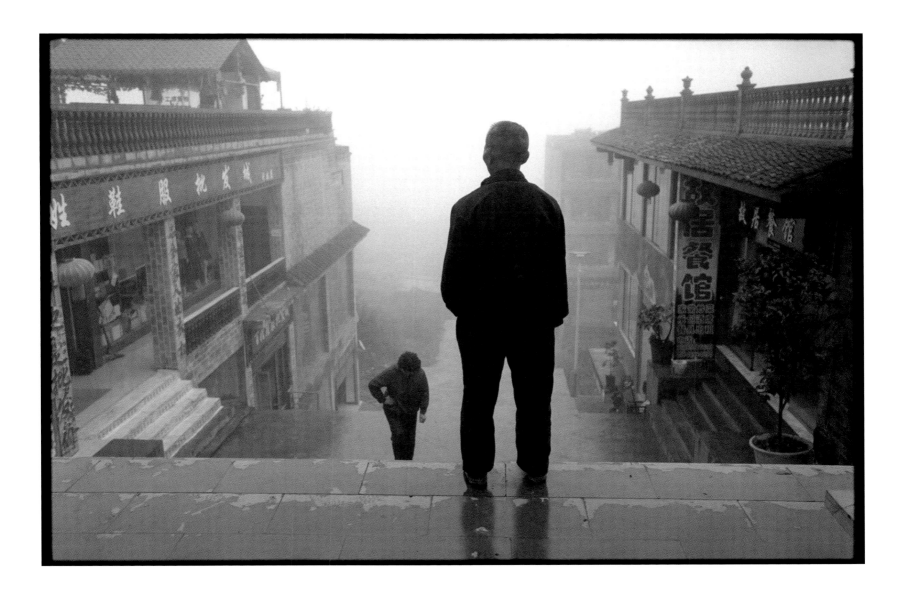

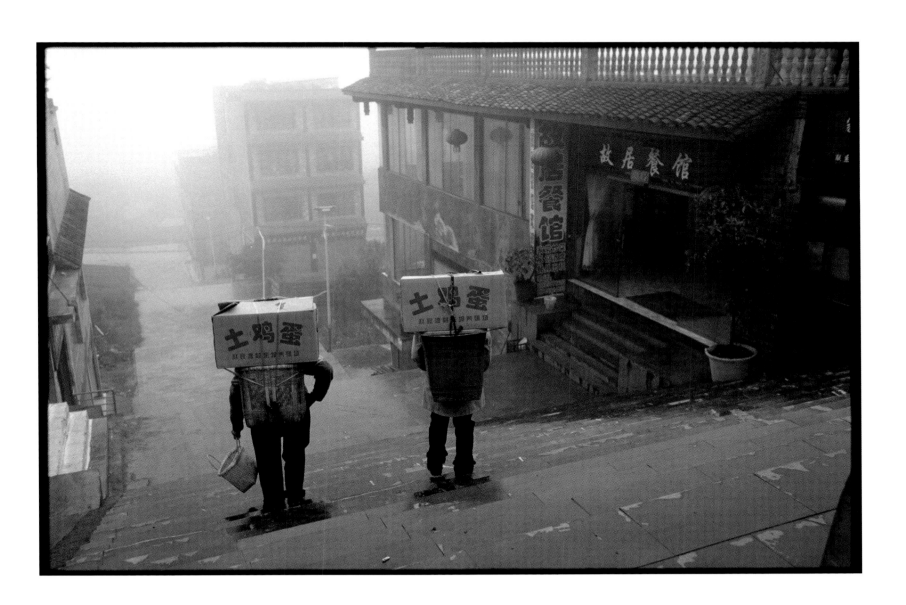

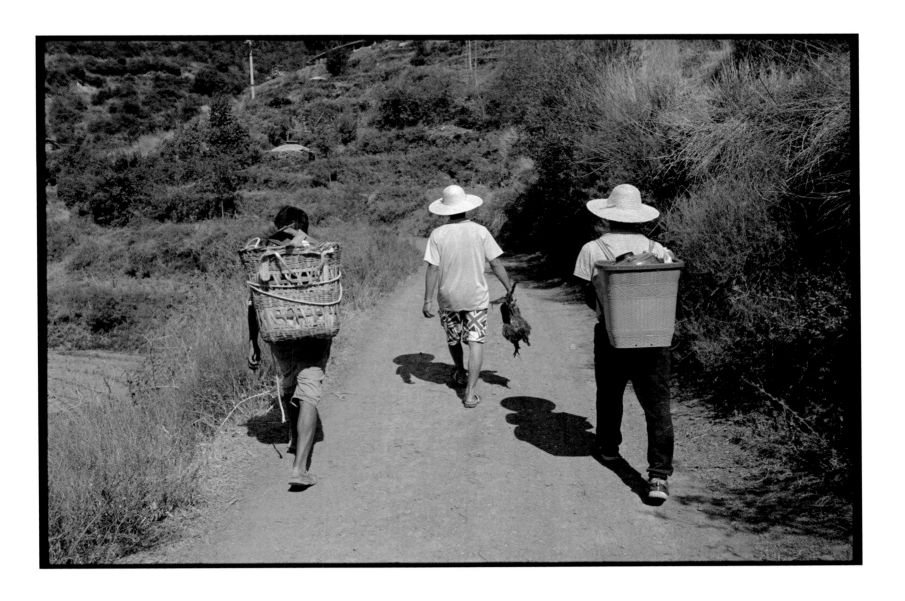

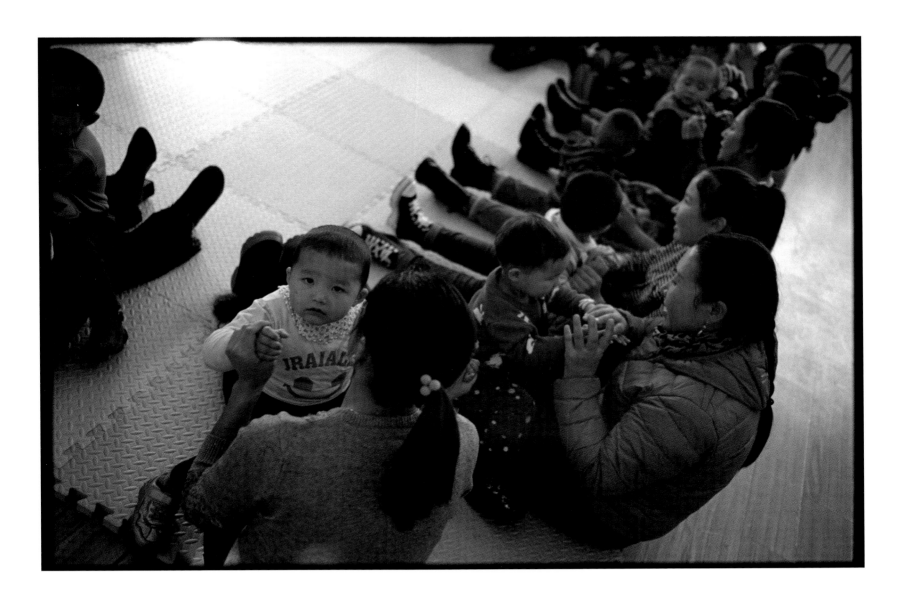

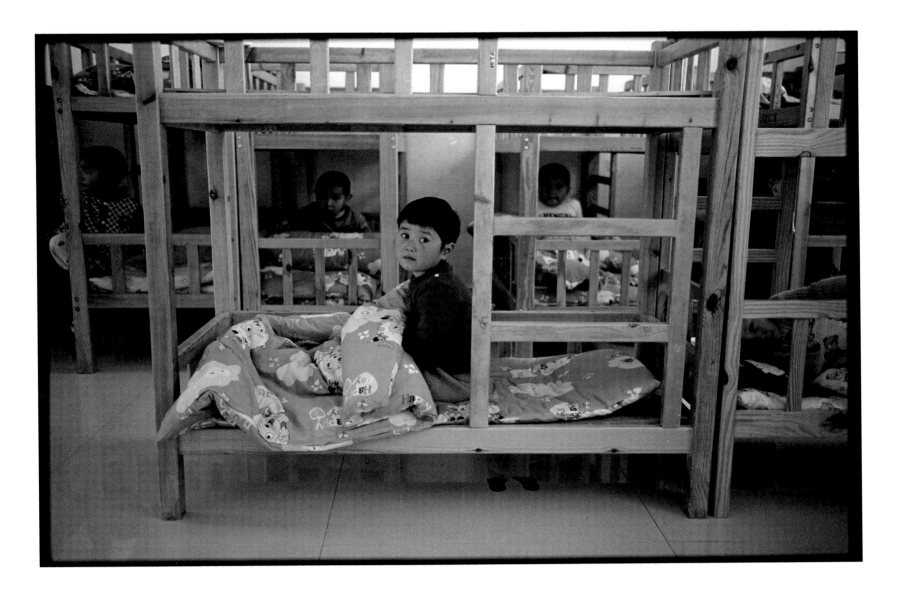

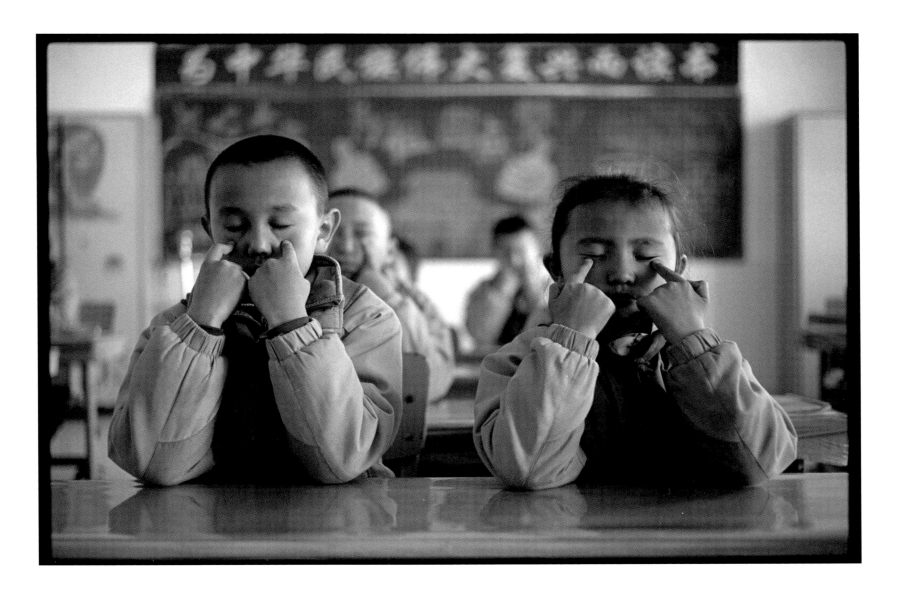

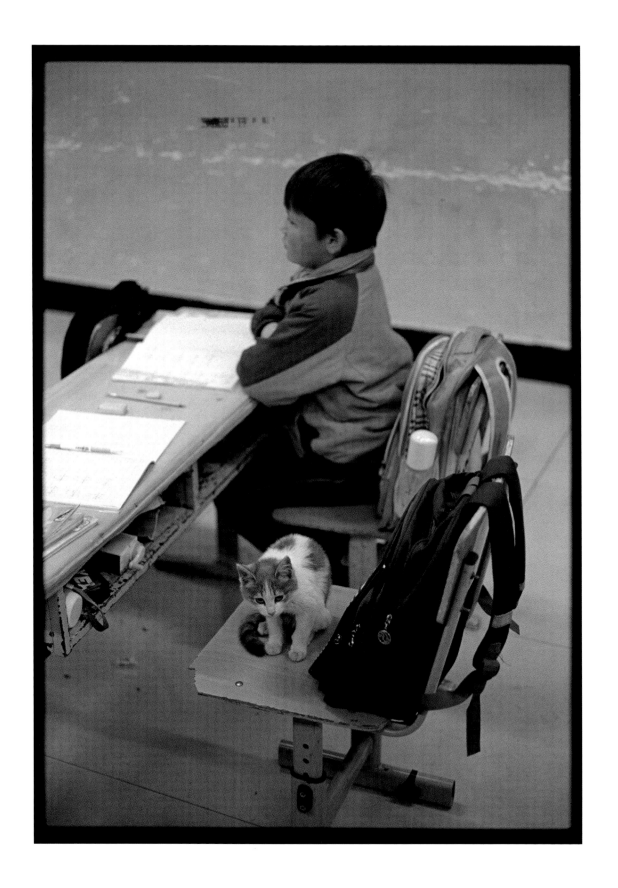

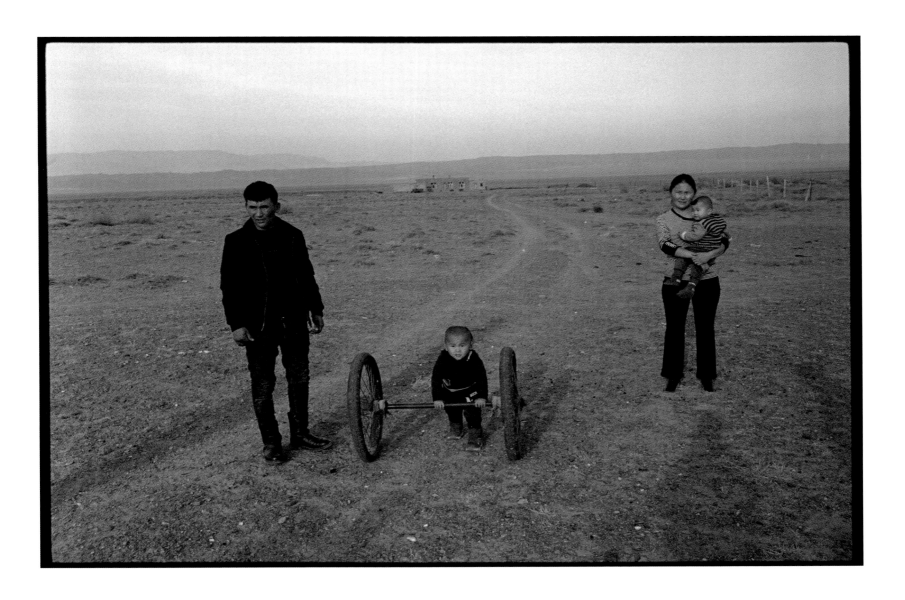

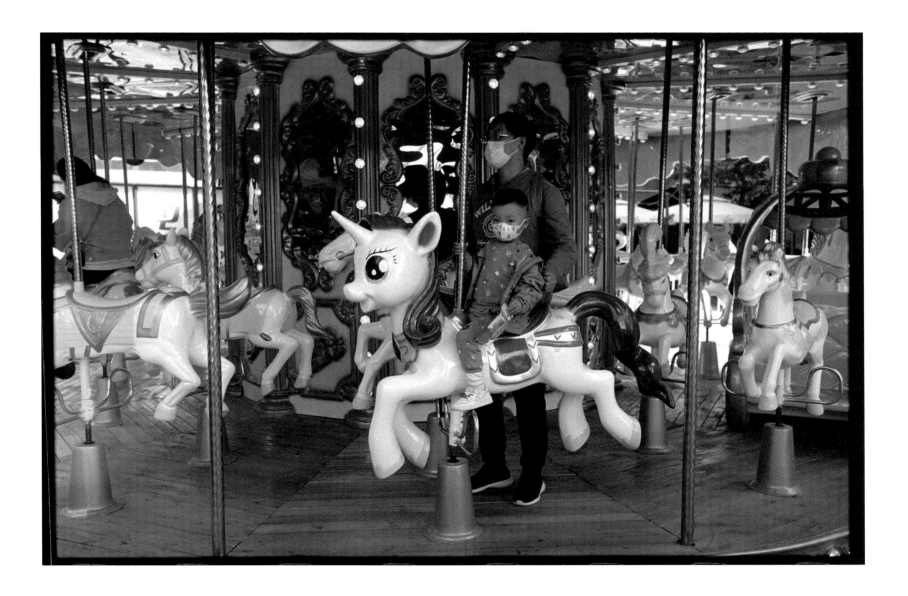

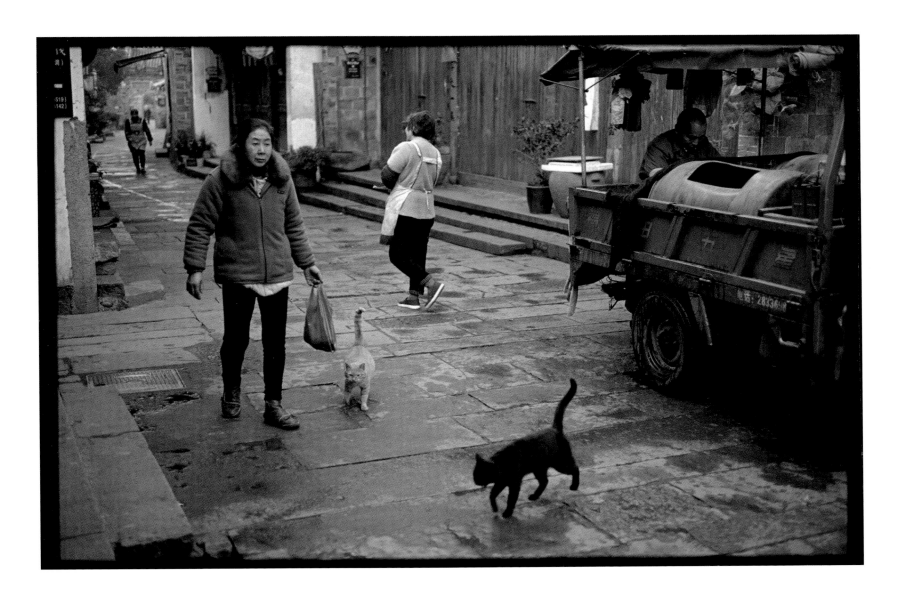

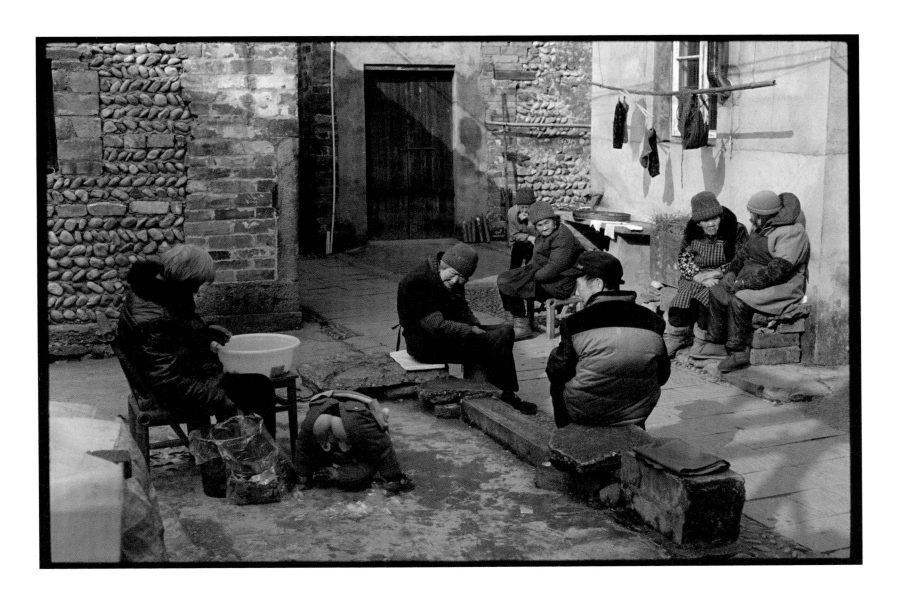

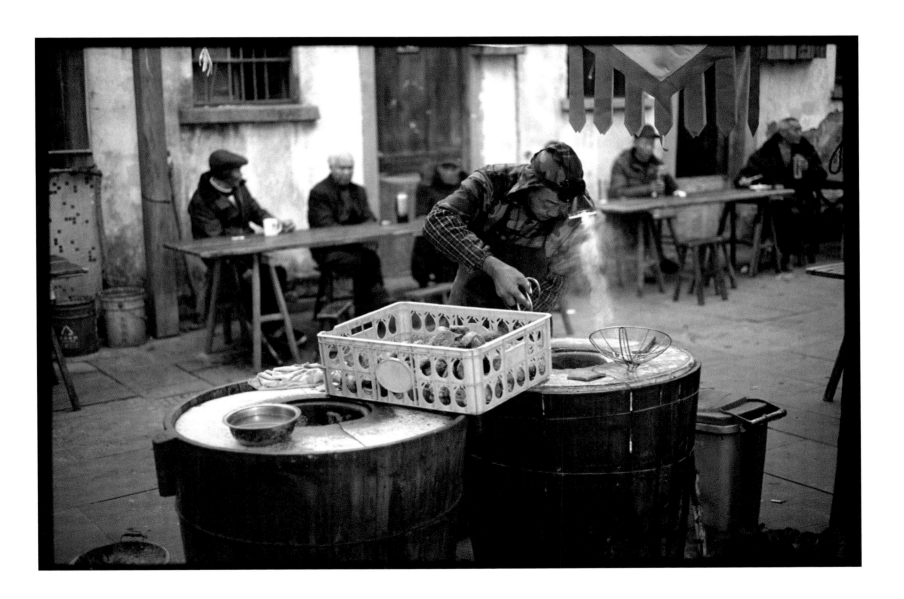

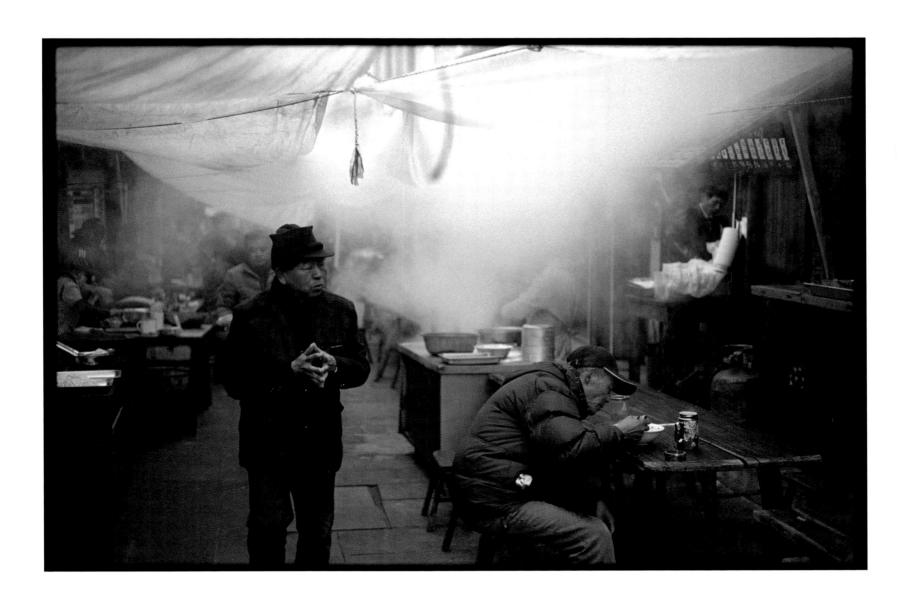

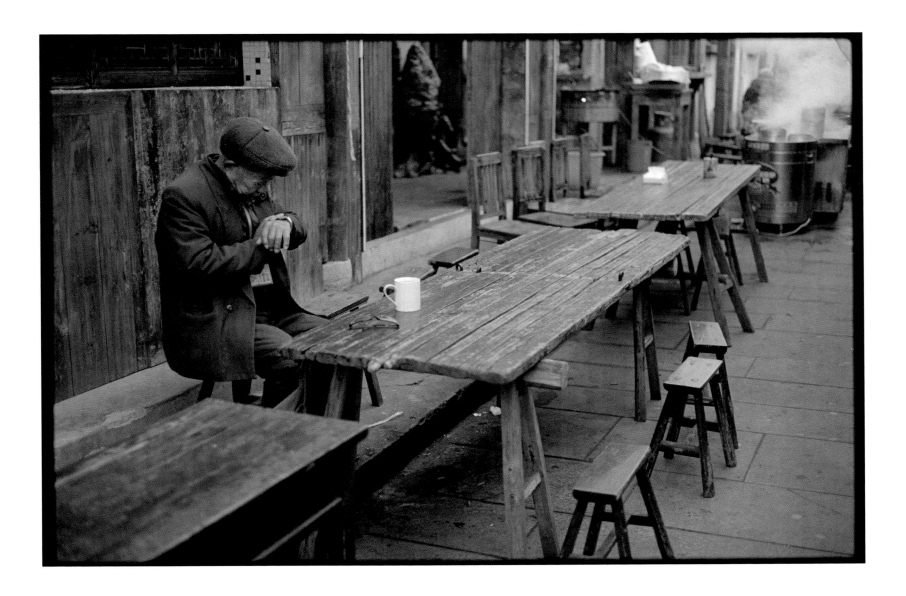

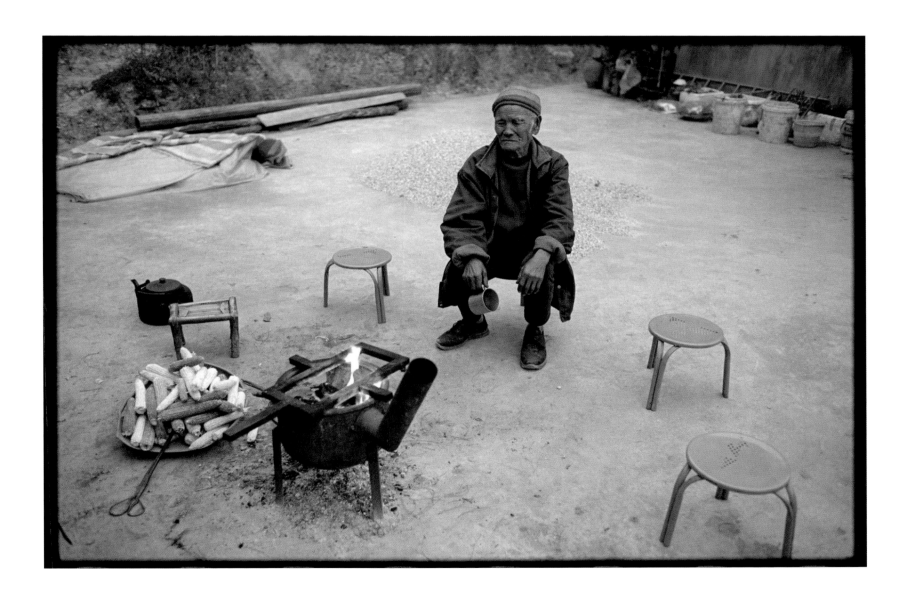

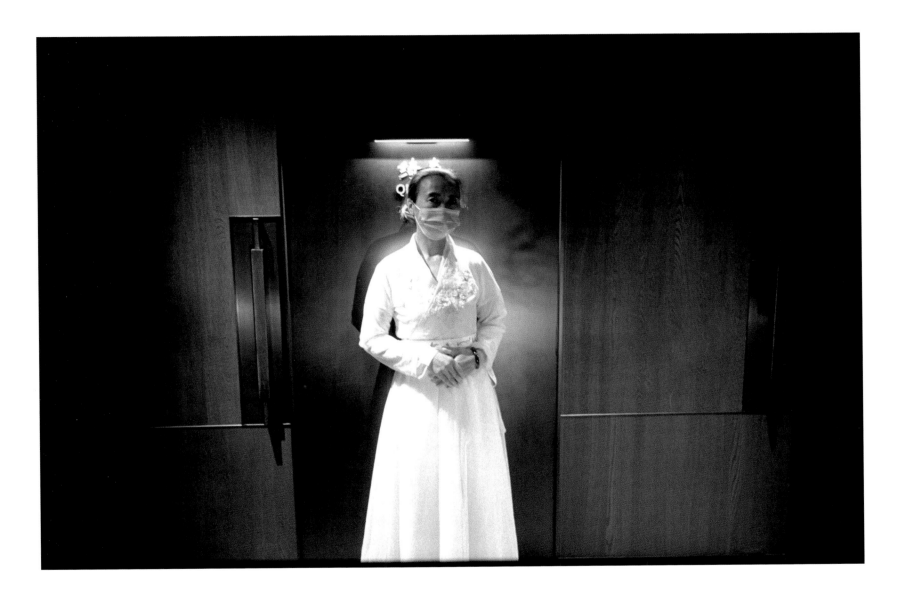

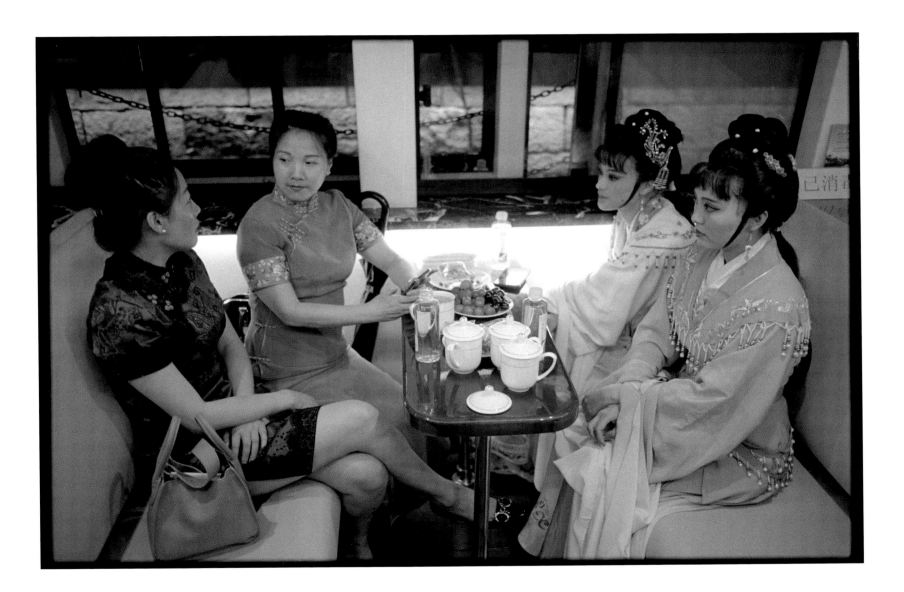

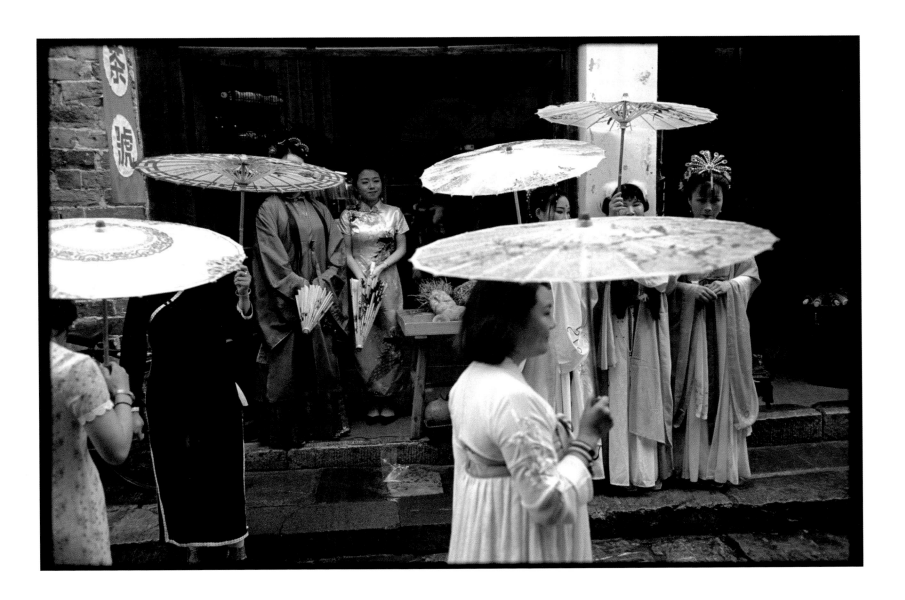

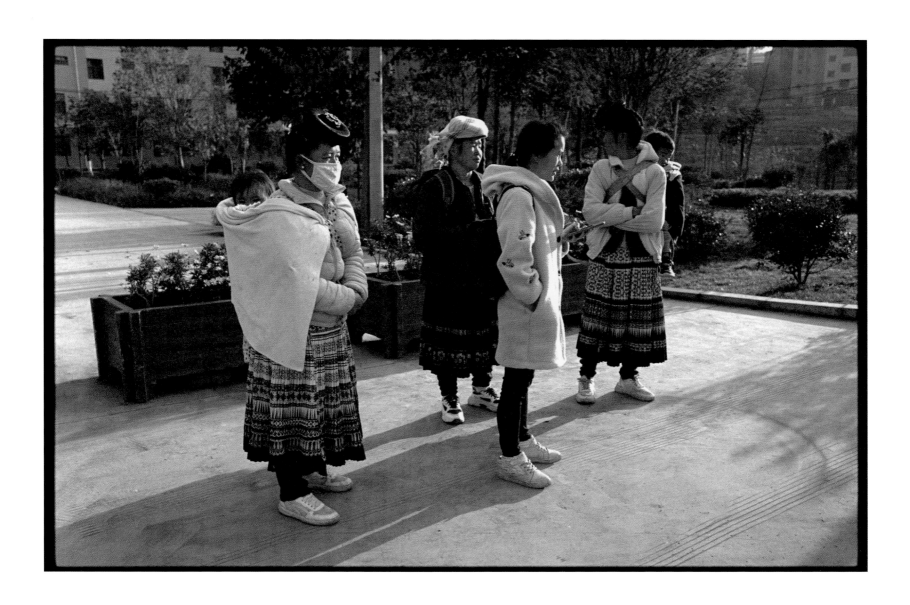

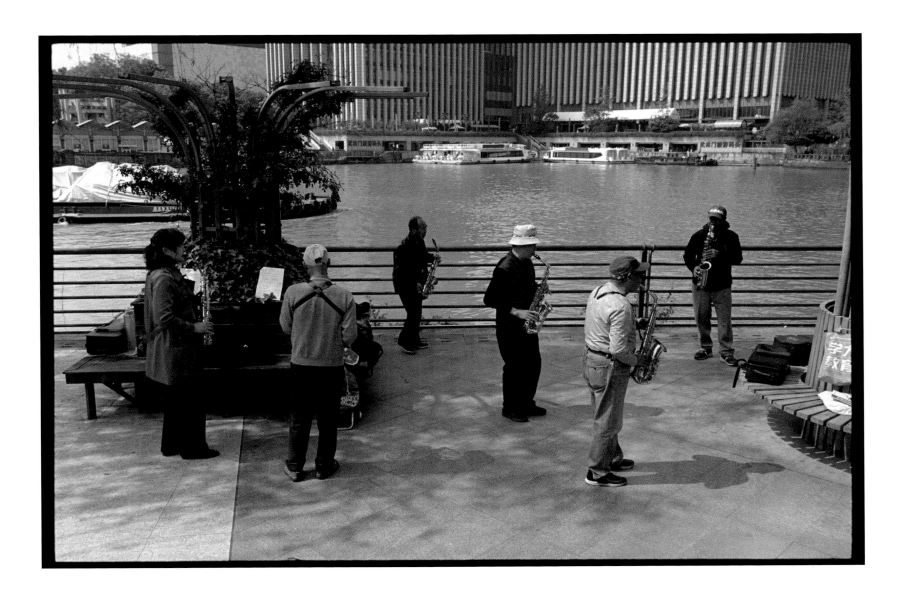

图片索引

031. 江苏省 江都市 1984 年

033. 江苏省 江都市 1984 年

035. 江苏省 江都市 长途汽车站 1984 年

037. 吉林省 长春市 火车站 1986 年

039. 吉林省 长春市 火车站 1986 年

041. 吉林省 长春市 搬运工人 1986 年

043. 北京市 八达岭长城 1986 年

045. 北京市 八达岭长城 1986 年

047. 北京市 天坛公园 回音壁 1986 年

049. 北京市 天坛公园 1986 年

051. 北京市 地铁 1986 年

053. 深圳市 火车站 1987 年

055. 深圳市 1987 年

057. 广东省 农村幼儿园 1988 年

059. 广东省 农村幼儿园 1988 年

061. 北京市 钢琴音乐会 2010 年

063. 北京市 宠物店 2011 年

065. 四川省 北川县 地震遗址 2011 年

067. 四川省 什邡市 地震遗址 2011 年

069. 四川省 成都市 茶馆 采耳 2011 年

071. 四川省 成都市 茶馆 书法 2011 年

073. 重庆市 2011 年

075. 重庆市 2011 年

077. 重庆市 麻将馆 2011 年

079. 重庆市 棒棒军 2011 年

081. 重庆市 女棒棒军 2011 年

083. 重庆市 棒棒军 2011 年

085. 重庆市 看书的棒棒军 2011 年

087. 重庆市 2011 年

089. 重庆市 2011 年

091. 重庆市 2011 年

093. 重庆市 广场舞 2011 年

095. 重庆市 2011 年

097. 湖北省 武汉市 2011 年

099. 北京市 面馆 2011 年

101. 上海市 2012 年

103. 上海市 2012 年

105. 上海市 2012 年

107. 上海市 2012 年

109. 上海市 2012 年

111. 上海市 2012 年

113. 上海市 买蟋蟀的父子 2012 年

115. 江苏省 苏州市 2012 年

117. 江苏省 苏州市 2012 年

119. 云南省 大理市 2013 年

121. 云南省 丽江市 野生雀鸟 2013 年

123. 北京市 2013 年

125. 浙江省 杭州市 中药店 2013 年

127. 浙江省 杭州市 2013 年

129. 浙江省 杭州市 西湖 2013 年

131. 浙江省 杭州市 2013 年

133. 浙江省 杭州市 2013 年

135. 青海省 化隆县 藏族祖母为孙女佩戴护身符 2013 年

137. 青海省 西宁市 唇裂手术后的小孩 2013 年

139. 青海省 西宁市 腭裂手术前的女孩 2013 年

141. 青海省 西宁市 唇裂手术前的男孩 2013 年

143. 内蒙古自治区 腾格里沙漠 2015 年

145. 广东省 连州市 打牌 2015 年

147. 广东省 连州市 2015 年

149. 浙江省 宁波市 东钱湖 2016 年

151. 甘肃省 民勤县 腾格里沙漠 固沙工人 2016 年

153. 甘肃省 民勤县 腾格里沙漠 固沙工人 2016 年

155. 西藏自治区 拉萨市 布达拉宫前 2016 年

157. 西藏自治区 拉萨市 2016 年

159. 西藏自治区 拉萨市 茶馆 2016 年

161. 西藏自治区 拉萨市 盲人学校 弱视学生 2016 年

163. 黑龙江省 哈尔滨市 2016 年

165. 黑龙江省 哈尔滨市 2016 年

167. 黑龙江省 哈尔滨市 2016 年

169. 云南省 迪庆藏族自治州 2017 年

171. 云南省 迪庆藏族自治州 2017 年

173. 云南省 迪庆藏族自治州 2017 年

175. 安徽省 寿县 古城墙 2017 年

177. 安徽省 六安市 2017 年

179. 江西省 鄱阳县 赣剧演员 2017 年

181. 江西省 鄱阳县 赣剧表演结束后 2017 年

183. 江西省 鄱阳县 鄱阳湖 鸬鹚捕鱼 2017 年

185. 江西省 鄱阳县 鄱阳湖 2017 年

187. 贵州省 关岭布依族苗族自治县 布依族 2018 年

189. 贵州省 关岭布依族苗族自治县 布依族 2018 年

191. 贵州省 关岭布依族苗族自治县 2018 年

193. 贵州省 兴义市 2018 年

195. 贵州省 兴义市 2018 年

197. 云南省 玉龙县 农民 2019 年

199. 新疆维吾尔自治区 阿勒泰地区 吉木乃县 亲子活动 2019 年

201. 新疆维吾尔自治区 阿勒泰地区 吉木乃县 幼儿园午睡 2019 年

203. 新疆维吾尔自治区 阿勒泰地区 吉木乃县 护眼操 2019 年

205. 新疆维吾尔自治区 阿勒泰地区 吉木乃县 教室里取暖的流浪猫 2019 年

207. 新疆维吾尔自治区 阿勒泰地区 吉木乃县 草原上的牧民 2019 年

209. 北京市 疫情 2020 年

211. 浙江省 衢州市 廿八都古镇 鱼贩与猫 2020 年

213. 浙江省 开化县 霞山村 2020 年

215. 浙江省 游埠古镇 早茶 烘烤传统酥饼 2020 年

217. 浙江省 游埠古镇 早茶 2020 年

219. 浙江省 游埠古镇 早茶 2020 年

221. 云南省 禄劝彝族苗族自治县 生火取暖 的老贫农 2021 年

223. 江苏省 无锡市 疫情下的餐馆 2021 年

225. 江苏省 无锡市 夜游古运河 2021 年

227. 湖北省 赤壁市 2021 年

229. 云南省 武定县 苗族妇女 2021 年

231. 浙江省 杭州市 京杭大运河 2021 年

个人简介

1983—1985年

合众国际社（United Press International）摄影记者、助理新闻图片编辑。

1985—2004年

路透社（Reuters）助理新闻图片编辑，责任新闻图片编辑，摄影记者，首席摄影记者，亚太地区新闻图片副总编辑。

1998年

世界新闻摄影比赛（World Press Photo Contest）评委。

2000—2018年

世界新闻摄影比赛大师班（World Press Photo Joop Swart Masterclass）学员提名委员会成员。

2003年

世界新闻摄影比赛（World Press Photo Contest）评委。

2004—2008年

盖蒂图片社（Getty Images）大中华地区首席摄影记者、新闻图片总监。

2008年—现在

独立摄影师。

Captions

031. Jiangdu, Jiangsu Province 1984

033. Jiangdu, Jiangsu Province 1984

035. Jiangdu, Jiangsu Province - Coach station 1984

037. Changchun, Jilin Province - Train station 1986

039. Changchun, Jilin Province - Train station 1986

041. Changchun, Jilin Province - Porter 1986

043. Beijing - The Great Wall 1986

045. Beijing - The Great Wall 1986

047. Beijing - The Temple of Heaven - The Echo
 Wall 1986

049. Beijing - The Temple of Heaven 1986

051. Beijing - Metro 1986

053. Shenzhen - Train station 1987

055. Shenzhen 1987

057. Guangdong Province - Village nursery 1988

059. Guangdong Province - Village nursery 1988

061. Beijing - Piano concert 2010

063. Beijing - Pet Shop 2011

065. Beichuan County, Sichuan Province -
 Earthquake ruins 2011

067. Shifang, Sichuan Province - Earthquake ruins
 2011

069. Chengdu, Sichuan Province - Ear picking at a
 teahouse 2011

071. Chengdu, Sichuan Province - Calligraphy at a
 teahouse 2011

073. Chongqing 2011

075. Chongqing 2011

077. Chongqing - Mahjong parlour 2011

079. Chongqing - Porters 2011

081. Chongqing - Woman porter 2011

083. Chongqing - Porter at work 2011

085. Chongqing - Porters reading 2011

087. Chongqing 2011

089. Chongqing - Pedicure 2011

091. Chongqing 2011

093. Chongqing - Ballroom dancing 2011

095. Chongqing 2011

097. Wuhan, Hubei Province 2011

099. Beijing - Noodles restaurant 2011

101. Shanghai 2012

103. Shanghai 2012

105. Shanghai 2012

107. Shanghai 2012

109. Shanghai 2012

111. Shanghai 2012

113. Shanghai - Father and son buying pet crickets 2012

115. Suzhou, Jiangsu Province 2012

117. Suzhou, Jiangsu Province 2012

119. Dali, Yunnan Province 2013

121. Lijiang, Yunnan Province - Wild birds 2013

123. Beijing 2013

125. Hangzhou, Zhejiang Province - Chinese herbal medicine shop 2013

127. Hangzhou, Zhejiang Province 2013

129. Hangzhou, Zhejiang Province - The West Lake 2013

131. Hangzhou, Zhejiang Province 2013

133. Hangzhou, Zhejiang Province 2013

135. Hualong County, Qinghai Province - Tibetan girl receiving an amulet from Grandma 2013

137. Xining, Qinghai Province - Toddler after cleft lip operation 2013

139. Xining, Qinghai Province - Tibetan girl before cleft palate operation 2013

141. Xining, Qinghai Province - Tibetan boy before cleft lip operation 2013

143. Tengger Desert, Inner Mongolia Autonomous Region 2015

145. Liangzhou, Guangdong Province - Poker games 2015

147. Lianzhou, Guangdong Province 2015

149. Dongqian Lake, Ningbo, Zhejiang Province 2016

151. Tengger Desert, Minqin County, Gansu Province - Afforestation worker 2016

153. Tengger Desert, Minqin County, Gansu Province - Afforestation workers 2016

155. Lhasa, Tibet autonomous region - The Potala Palace 2016

157. Lhasa, Tibet autonomous region - Pilgrims 2016

159. Lhasa, Tibet autonomous region - Teahouse 2016

161. Lhasa, Tibet autonomous region - Visually impaired students at a school for the blind 2016

163. Harbin, Heilongjiang Province 2016

165. Harbin, Heilongjiang Province 2016

167. Harbin, Heilongjiang Province 2016

169. Diqing Tibetan Autonomous Prefecture, Yunnan Province 2017

171. Diqing Tibetan Autonomous Prefecture, Yunnan Province 2017

173. Diqing Tibetan Autonomous Prefecture, Yunnan Province 2017

175. Shou County, Anhui Province - Ancient city wall 2017

177. Luan, Anhui Province - The Chinese dream 2017

179. Poyang County, Jiangxi Province - Jiangxi Opera singer 2017

181. Poyang County, Jiangxi Province - After a Jiangxi Opera performance 2017

183. The Poyang Lake, Jiangxi Province - Cormorant fishing 2017

185. The Poyang Lake, Jiangxi Province 2017

187. Guanling Buyi and Miao Autonomous County, Guizhou Province - Buyi ethnic minority 2018

189. Guanling Buyi and Miao Autonomous County, Guizhou Province - Buyi ethnic minority 2018

191. Guanling Buyi and Miao Autonomous County, Guizhou Province 2018

193. Xingyi, Guizhou Province 2018

195. Xingyi, Guizhou Province 2018

197. Yulong County, Yunnan Province - Farmers 2019

199. Jeminay County, Altay Prefecture, Xinjiang Uygur Autonomous Region - Parent child relationship building activities 2019

201. Jeminay County, Altay Prefecture, Xinjiang Uygur Autonomous Region - Afternoon nap at a nursery 2019

203. Jeminay County, Altay Prefecture, Xinjiang Uygur Autonomous Region - Eye exercise at a school 2019

205. Jeminay County, Altay Prefecture, Xinjiang Uygur Autonomous Region - Stray cat keeping warm at a school 2019

207. Jeminay County, Altay Prefecture, Xinjiang Uygur Autonomous Region - Nomads 2019

209. Beijing - Fairground during COVID-19 pandemic 2020

211. Nianbadu Town, Quzhou, Zhejiang Province - Fishmonger and cats 2020

213. Xiashan Village, Kaihua County, Zhejiang Province 2020

215. Youbu Town, Lanxi, Zhejiang Province - Baker working at dawn 2020

217. Youbu Town, Lanxi, Zhejiang Province - Locals having breakfast at teahouses 2020

219. Youbu Town, Lanxi, Zhejiang Province - Old customer at a teahouse 2020

221. Luquan Yi and Miao Autonomous County, Yunnan Province - Old farmer 2021

223. Wuxi, Jiangsu Province - Restaurant waitress working during COVID-19 pandemic 2021

225. Wuxi, Jiangsu Province - Night cruise on an ancient canal 2021

227. Chibi, Hubei Province - Cosplay 2021

229. Wuding County, Yunnan Province - Miao ethnic minority 2021

231. Hangzhou, Zhejiang Province - The Beijing-Hangzhou Grand Canal 2021

Biography

1983 – 1985

United Press International - photographer/sub-editor

1985 – 2004

Reuters - photographer/sub-editor, editor-in-charge, chief photographer, deputy news pictures editor for Asia

1998

World Press Photo Contest jury member

2000 – 2018

World Press Photo Joop Swart Masterclass nomination committee member

2003

World Press Photo Contest jury member

2004 – 2008

Getty Images - chief photographer/news photo director for Greater China

2008 – Present

Independent photographer

未经许可，不得以任何方式复制或抄袭本书之部分或全部内容。
版权所有，侵权必究。

图书在版编目（CIP）数据

慢游中国：只道寻常 / 王身敦著 . -- 北京：电子工业出版社，2022.9
ISBN 978-7-121-44036-6

Ⅰ . ①慢… Ⅱ . ①王… Ⅲ . ①摄影集—中国—现代 Ⅳ . ① J421.8

中国版本图书馆 CIP 数据核字（2022）第 134121 号

读 者 服 务

读者在阅读本书的过程中如果遇到问题，可以关注"有艺"公众号，通过公众号中的"读者反馈"功能与我们取得联系。此外，通过关注"有艺"公众号，您还可以获取艺术教程、艺术素材、新书资讯、书单推荐、优惠活动等相关信息。

扫一扫关注"有艺"

投稿、团购合作：请发邮件至 art@phei.com.cn。

责任编辑：田　蕾
印　　刷：北京利丰雅高长城印刷有限公司
装　　订：北京利丰雅高长城印刷有限公司
出版发行：电子工业出版社
　　　　　北京市海淀区万寿路 173 信箱　　邮　编：100036
开　　本：787×1092　1/12　　印张：20　　字　数：240 千字
版　　次：2022 年 9 月第 1 版
印　　次：2022 年 9 月第 1 次印刷
定　　价：198.00 元

凡所购买电子工业出版社图书有缺损问题，请向购买书店调换。若书店售缺，请与本社发行部联系，联系及邮购电话：（010）88254888，88258888。

质量投诉请发邮件至 zlts@phei.com.cn，盗版侵权举报请发邮件至 dbqq@phei.com.cn。

本书咨询联系方式：（010）88254161 ～ 88254167 转 1897。